AFRICAN ART
IN SOUTH AFRICA

By E. J. de Jager

Professor of Anthropology at the University of Fort Hare

C. STRUIK (PTY) LTD CAPE TOWN, 1973

C. STRUIK (PTY) LTD
Africana Specialist & Publisher

FIRST PUBLISHED 1973

ISBN 0 86977 025 X

Lithographic Reproduction: Photo Sepro (Pty) Ltd, Cape Town
Design and Layout: James Giles
Printed and bound by Printpak (Cape) Ltd, Cape Town

Contents

Acknowledgements

The author makes grateful acknowledgement to the owners of pieces illustrated, agents and photographers, etc. for permission to use photographs. The numbers refer to illustrations as per list of illustrations. It has not been possible in every case to trace the owners, and such lack of specific acknowledgement has not been a deliberate oversight. Due acknowledgement is made here to such persons and instances.

The South African National Gallery, Cape Town: 10, 19, 25, 26, 27, 33, 34, 38, 80, 81, 93, 97, 98.

Gallery of the University of Fort Hare: 1, 2, 3, 4, 5, 6, 11, 12, 13, 14, 15, 16, 17, 20, 31, 32, 35, 36, 37, 40, 41, 42, 43, 44, 48, 49, 50, 53, 57, 58, 59, 60, 61, 62, 63, 64, 66, 70, 71, 72, 73, 74, 76, 91, 94, 95, 96, 101, 110, 111, 112, 113, 114, 119, 122, 123, 127, 128, 129.

Gallery 101, Johannesburg: 18, 32, 35, 61, 62, 63, 73, 104, 105, 106, 107, 108, 109, 124.

The Goodman Gallery, Johannesburg: 20, 21, 22, 23, 24, 48, 49, 50, 51, 52, 53, 54, 67, 68, 102, 126.

South African Department of Information: 7, 8, 9, 28, 29, 30, 39, 55, 56, 65, 69, 74, 79, 103, 125.

Miss L. Peirson, Ndaleni Art School: 95, 96, 110, 112, 114, 123, 128, 129.

Mr Egon Guenther: 45, 46, 47, 75, 77, 78, 82, 83, 84, 99, 100.

P. H. Schaudraff (Photo Hein, Pinetown): 85, 86, 87, 88, 89, 90 92.

Mrs P. Baillon: 14, 15, 16, 17.

Dr W. Bodenstein: 89, 92.

Mr H. Oppenheimer: 105.

Howard Timmins, Publishers, Cape Town: 14, 15, 16, 17.

Dr Kurt Strauss: 85, 87.

Professor H. Aicher: 86, 90.

Mr D. M. Groenewald: 51.

Braken Mines, Transvaal: 106.

Appelsbosch Mission, Natal: 88.

Dept of Fine Arts, University of Fort Hare: 66.

Eli Weinberg: 101.

Dr P. C. Wagener: 52.

Mr P. D. Banghart: 71.

Carlton Centre Gallery: 31, 36, 41.

Melvyn Penn: 105.

List of Illustrations

In some cases the originals are overseas or privately owned and since their whereabouts are not known, we are unable to give the specifications of these works.

1. NGCOBO, E. **Festive Spirit.** 1963. Oil. 122 x 61 cm. *Collection: University of Fort Hare.*

2. PEMBA, G. M. **Old Man.** Water-colour. 35 x 27 cm. *Collection: University of Fort Hare.*

3. PEMBA, G. M. **Dancing Women.** Oil. 48 x 38 cm. *Collection: University of Fort Hare.*

4. PEMBA, G. M. **Xhewu.** Oil. 46 x 37 cm. *Collection: University of Fort Hare.*

5. PEMBA, G. M. **Woman.** 1940. Water-colour. 37 x 26 cm. *Collection: University of Fort Hare.*

6. MGUDLANDLU, G. **The Birds.** Oil. 81 x 34 cm. *Collection: University of Fort Hare.*

7. MGUDLANDLU, G. **Newly-weds.** 1964. Oil.

8. MOTJUOADI, A. **Playing Cards.** 1966. Pencil. 73 x 106 cm. *Private Collection.*

9. MOTJUOADI, A. **Township Musicians.** 1966. Pencil. 75 x 108 cm. *Private Collection.*

10. SEKOTO, G. **Four Men and a Guitar.** Oil. 51 x 58 cm. *Collection: South African National Gallery.*

11. NDABA, G. **Umbrellas.** Pencil. 48 x 35 cm. *Collection: University of Fort Hare.*

12. NDABA, G. **Women Reading.** Pencil. 48 x 35,5 cm. *Collection: University of Fort Hare.*

13. BHENGU, G. **Homeward Bound.** 1941. Water-colour. 18 x 38 cm. *Collection: University of Fort Hare.*

14. BHENGU, G. **Ntombentle.** Sepia. 30 x 38 cm. *Collection: University of Fort Hare.*

15. BHENGU, G. **Umyeku.** Sepia. 30 x 38 cm. *Collection: University of Fort Hare*

16. BHENGU, G. **Tsi-viva.** Sepia. 30 x 38 cm. *Collection: University of Fort Hare.*

17. BHENGU, G. **Bearded Beau.** Sepia. 30 x 38 cm. *Collection: University of Fort Hare.*

18. MOTAU, J. **Women.** 1968. Mixed media. 82,5 x 52 cm. *Private Collection.*

19. MOTAU, J. **Man in Jail.** 1967. Charcoal. 152,5 x 101,6 cm. *Collection: South African National Gallery.*

20. MOTAU, J. **Classroom.** 1968. Charcoal. 91 x 91 cm. *Collection: University of Fort Hare.*

21. MOTAU, J. **Mother and Child.** 1967. Charcoal.

22. MOTAU, J. **Advantage of Education.** 1967. Charcoal.

23. MOTAU, J. No title. 1967. Charcoal.

24. MOTAU, J. **The Bed.** 1968. Charcoal.

25. DUMILE, M. **The Resurrection.** Triptych. 1965. Charcoal. 58,4 x 38,1 cm. *Collection: South African National Gallery.*

26. DUMILE, M. **Woman and Children.** Crayon. 118,5 x 101,8 cm. *Collection: South African National Gallery.*

27. DUMILE, M. **Railway Accident.** 1966. Crayon. 102,4 x 237,2 cm. *Collection: South African National Gallery.*

28. DUMILE, M. **Harpy.** Charcoal.

29. DUMILE, M. **Kwa Mashu.** 1966. Crayon. *(Composition for a sculpture).*

30. DUMILE, M. **Ogre.** 1965. Charcoal.

31. MBELE, D. **Boy with a Suitcase.** Chalk. 32 x 50 cm. *Collection: University of Fort Hare.*

32. DUMILE, M. **African Guernica.** (Three details). Charcoal. 3,3 x 2,7 m. *Collection: University of Fort Hare.*

33. SEKOTO, G. **Street Scene.** Oil. 30,5 x 40,5 cm. *Collection: South African National Gallery.*

34. DUMILE, M. **Animals.** 1966. Crayon. 112 x 103,5 cm. *Collection: South African National Gallery.*

35. SITHOLE, L. **Dog.** 1962. Acrylic. 91,5 x 73,5 cm. *Collection: University of Fort Hare.*

36. MBELE, D. **Friends.** Chalk. 71 x 55 cm. *Collection: University of Fort Hare.*

37. SIBISI, P. **People I meet.** 1972. Ink. 43 x 61 cm. *Collection: University of Fort Hare.*

38. MACALA, B. **Head.** 1969. Crayon. 68,5 x 48,4 cm. *Collection: South African National Gallery.*

39. MACALA, B. **Two Heads.** 1972. Crayon.

40. MBATHA, A. **John and the Beast.** Serigraph. 40,5 x 35 cm. *Collection: University of Fort Hare.*

41. MBELE, D. **Nude.** Chalk. 71 x 51 cm. *Collection: University of Fort Hare.*

42. MBATHA, E. **Newcomer.** 1972. Etching. 35,5 x 20 cm. *Collection: University of Fort Hare.*

43. MBATHA, E. **Self portrait.** 1972. Etching. 35 x 30 cm. *Collection: University of Fort Hare.*

44. MBATHA, A. **Invitation.** Linocut. 48 x 28 cm. *Collection: University of Fort Hare.*

45. LEGAE, E. **The Mourners.** 1966.

46. LEGAE, E. **Washer Women.** 1966.

47. LEGAE, E. **Regret.** 1966.

48. SAOLI, W. **Sunrise to Sunset.** 1972. Water-colour and Ink. 47 x 36 cm. *Collection: University of Fort Hare.*

49. SHILAKOE, C. **Figure.** 1968. Etching. 38 x 24 cm. *Collection: University of Fort Hare.*

50. SHILAKOE, C. **We are Leaving.** 1969. Etching. 28 x 21,5 cm. *Collection: University of Fort Hare.*

51. SHILAKOE, C. **My Donkey.** 1970. Linocut. 28 x 21 cm. *Collection: Mr D. M. Groenewald.*

52. SHILAKOE, C. **Loneliness.** 1971. Etching. 30,5 x 21,5 cm. *Collection: Dr P. C. Wagener.*

53. SAOLI, W. **Twilight.** Oil. 37 x 34 cm. *Collection: University of Fort Hare.*

54. SAOLI, W. **Mother and Child.** Chalk.

55. NGLOVU, A. **The Israelites Crossing the Red Sea.** Linocut.

56. SIBIYA, L. **Flight.** Wood panel.

57. NTULI, M. **Mother and Child.** 1967. Chalk. 72 x 48 cm. *Collection: University of Fort Hare.*

58. RAKGOATHE, Dan. **Death Messengers.** 1970.
Linocut. 40 x 34 cm.
Collection: University of Fort Hare.

59. RAKGOATHE, Dan. **Trap of Conscience.** 1972.
Linocut. 40 x 35 cm.
Collection: University of Fort Hare.

60. MALGAS, M. W. **Korsten Village.** Water-colour.
55 x 37 cm.
Collection: University of Fort Hare.

61. TSHABALALA, E. No title. 1971. Ink.
48 x 36 cm.
Collection: University of Fort Hare.

62. TSHABALALA, E. No title. 1971. Ink.
48 x 36 cm.
Collection: University of Fort Hare.

63. MASEKO, J. **Township.** Water-colour.
48 x 33 cm.
Collection: University of Fort Hare.

64. NXAMALO, C. **The Shembe Story.** Linocut.
62 x 40,5 cm.
Collection: University of Fort Hare.

65. KAFENJE, I. **A Battle Long Ago.** Linocut.

66. MABUNU, M. **African Magic.** 1972. Linocut.
38 x 30,5 cm.
Collection: University of Fort Hare.

67. MATSOSO, L. **Face of a Charging Zulu Induna.**
1971. Ink.

68. MATSOSO, L. **Man Smoking Pipe.** 1971. Ink.

69. MAQHUBELA, L. **Peter's Denial.** Chalk.

70. TINI, JULIUS. **Kraal Scene.** Oil.
40 x 50 cm.
Collection: University of Fort Hare.

71. NOLUTSHUNGU, H. **Standing Figures.** 1972.
Etching. 25,5 x 55,5 cm.
Private Collection.

72. NOLUTSHUNGU, H. **Reading the Sermon.**
1972. Etching. 25,5 x 35,5 cm.
Collection: Mr P. D. Banghart.

73. NTUKWANA, H. **Composition.** Crayon.
62 x 98 cm.
Collection: University of Fort Hare.

74. MUAFANGEJO, J. **Vision of Eden.** 1968.
Linocut. 62 x 53 cm.
Collection: University of Fort Hare.

75. KUMALO, S. **Animal.** 1966. Chalk.
36 x 57 cm.

76. KUMALO, S. **Animal.** 1966. Chalk.
Collection: University of Fort Hare.

77. KUMALO, S. **Head.** 1965. Chalk.

78. KUMALO, S. **The Dancer** (detail). 1965.
Bronze. 46 cm.

79. KUMALO, S. **Praying Woman.** Bronze.
30,5 cm.

80. KUMALO, S. **Zulu Chief.** 1963. Bronze.
66,5 cm.
Collection: South African National Gallery.

81. KUMALO, S. **Seated Woman.** Bronze.
56 cm.
Collection: South African National Gallery.

82. KUMALO, S. **Figure.** Bronze.

83. KUMALO, S. **Elongated Head.** Bronze.

84. KUMALO, S. **Squat Head.** 1966. Bronze.
46 cm.

85. ZONDI, MICHAEL. **Woman Bathing.**
Umthombothi.
Collection: Dr Kurt Strauss.

86. ZONDI, MICHAEL. **Madonna and Child.** Red
Ivory.
Collection: Professor H. Aicher.

87. ZONDI, MICHAEL. **The Publican.** (Detail).
Stinkwood.
Collection: Dr K. Strauss.

88. ZONDI, MICHAEL. Detail. Life-size Crucifix,
Hospital Chapel, Appelsbosch, Natal. Blackwood.

89. ZONDI, MICHAEL. **Rachel.** Red Ivory.
Collection: Dr W. Bodenstein.

90. ZONDI, MICHAEL. **Mother and Child.**
Umthombothi.
Collection: Prof. H. Aicher.

91. ZONDI, MANDLENKOSI. **The Orphan.** Red
Ivory. 25,5 cm.
Collection: University of Fort Hare.

92. ZONDI, MICHAEL. **Portrait of a Dying Man.**
Umthombothi.
Collection: Dr W. Bodenstein.

93. ZONDI, MICHAEL. **Ecstatic Woman.**
Umthombothi. 46,5 cm.
Collection: South African National Gallery.

94. ZONDI, MICHAEL. **Head of a Young Woman.**
Sneezewood. 38 cm.
Collection: University of Fort Hare.

95. MHLONGO, A. **Figure.** Wild Olive.
43,2 cm.
Collection: University of Fort Hare.

96. MHLONGO, A. **Man with a Beerpot.**
Umthombothi. 40,5 cm.
Collection: University of Fort Hare.

97. MACALA, B. **Mother and Child.** Bronze.
37 cm.
Collection: South African National Gallery.

98. MACALA, B. **Bull.** Bronze.
12,5 cm.
Collection: South African National Gallery.

99. LEGAE, E. **Head of a Wise Man.** 1965. Bronze.
33 cm.

100. LEGAE, E. **Young Man.** 1968. Bronze.
63,5 cm.

101. SHILAKOE, C. **Coming Out.** Rhodesian Teak.
48 cm.
Collection: University of Fort Hare.

102. SHILAKOE, C. **Totem Pole.** Rhodesian Teak.

103. SITHOLE, L. **Fat Head.** Sandstone.

104. SITHOLE, L. **Figure.**

105. SITHOLE, L. **"Thokozile" Delighted.** 1972.
Ironwood.
Collection: Mr H. Oppenheimer.

106. SITHOLE, L. **Wounded Buffalo.** 1971. Liquid
Steel. Maquette for 27,7 x 1,8 m.
Commision: Braken Mines, Transvaal.

107. SITHOLE, L. Group of Figurative Sculptures.

108. SITHOLE, L. **Figure.** Rhodesian Teak.

109. SITHOLE, L. **Figure.** Rhodesian Teak.

110. MOLATANA, K. **The Mourner.** Umthombothi.
26,5 cm.
Collection: University of Fort Hare.

111. MOLATANA, K. **Namasumbuka.** Katbosboom.
85 cm.
Collection: University of Fort Hare.

112. MOLATANA, K. **Ngwale.** Jacaranda.
53 cm.
Collection: University of Fort Hare.

113. KHALISHWAYO, R. **The Flutist.** 1972. Umduli.
56 cm.
Collection: University of Fort Hare.

114. RAPHELA, S. **Matome.** Jarawood.
44,5 cm.
Collection: University of Fort Hare.

115. SEDIBANE, S. **The Wrestlers.** 1959.
Ironwood. 38 cm.

116. SEDIBANE, S. **Wrestlers.** Red Ivory.

117. SEDIBANE, S. **The Boxers.** Red Ivory.

118. SEDIBANE, S. **North Sotho Girl.** Red Ivory.

119. SEDIBANE, S. **Pedi Woman.** Kiaat.
34 cm.
Collection: University of Fort Hare.

120. SEDIBANE, S. **Mary and Baby Jesus.** Red Ivory.

121. SEDIBANE, S. **The Dying Child.** Kiaat.

122. NGUZA, A. **Woman in Pains.** 1972. Acacia.
68,5 cm.
Collection: University of Fort Hare.

123. NDABA, G. **Family.** Jacaranda.
54,5 cm.
Collection: University of Fort Hare.

124. DUMILE, M. **Sculpture.** Terra Cotta.

125. NKOSI, S. **Man in Despair.** Red Clay.

126. SAOLI, W. **Seated Figures.**

127. NGCOBO, E. **Unomkhubulwana.** Umthombothi.
38 cm.
Collection: University of Fort Hare.

128. MLAMBO, P. **The Cradle.** Red Ivory.
84 cm.
Private Collection.

129. NGUBANE, N. **Starvation.** Jacaranda.
66 cm.
Collection: University of Fort Hare.

List of Artists

Underneath are listed the names of practising African artists. Work by all these artists have not been included in this volume, because of unavailability, etc.

Bangeni, Mtshali
Bhengu, Gerard
Dumile, Mslaba
Dibetsoe, Godfrey
Gumede, J.
Hlatshwayo, Isaac
Hlatywayo, John
Kafenje, Israel
Khalishwayo, R.
Keipedele, Tosby
Ketye, Duke
Kgame, Hosea
Kobeleli, Elijah
Koboka, Welcome
Koko, Siphiwe
Kumalo, Cyril
Kumalo, Sydney
Legae, Ezrom
Lerumo, Portia
Mabunu, M.
Macala, Benjamin
Magagula, Stephen
Makhubedu, E.
Malaza, Boniface
Malgas, M. W.
Manthatha, P.

Manyoni, B.
Maphiri, Joe
Maphiri, Solomon
Maqhubela, Louis
Masekela, T.
Maseko, J.
Mashishi, Raymond
Masinamela, Nathaniel
Masondo, G.
Matshaba, Rabie
Matsoso, L.
Matyila, Nondumiso
Mbambo, Wiseman
Mbatha, Azaria
Mbatha, Eric
Mbele, David
Mbuyisa, J.
Mgoduso, Sicelo
Mgudlandlu, Gladys
Mhlongo, A.
Mlambo, Patrick
Mnguni, Isiah
Mokhethi, C.
Molatana, K.
Molisi, Joseph
Mongano, P.

Motau, Julian
Motjuoadi, Andrew
Mphiri, S.
Msimang, George
Muafangejo, John
Mutwa, Credo
Mvusi, Selby
Ncapai, Z.
Ndaba, G.
Ndlazi, Jacob
Ndlovu, Albert
Ngatane, Ephraim
Ngcobo, Eric
Ngoxolo
Ngubane, N.
Nguza, A.
Nkosi, Stanley
Nolutshungu, H.
Ntukwana, H.
Ntuli, Michael
Nyatlo, Edwin
Nxumalo, C.
Pemba, G. M.
Phoshane, Salthiel
Pilane, Daniel
Rakgoathe, Dan

Raphalalani, M.
Raphela, Simon
Salang, J.
Saoli, Winston
Seeletse, Pauline
Sedibane, Solomon
Sedumedi
Segole, Ezekiel
Sekoto, Gerard
Shibambo, John
Shilakoe, Cyprian
Sibisi, P.
Sibiya, L.
Sihlali, Durant
Sithole, J. T. Bone
Sithole, Lucas
TeNehi, Edward
Tini, J.
Thovhakale, Moses
Tshabalala, A. J.
Tshabalala, Enoch
Walaza, Cousin
Zondi, Mandlenkozi
Zondi, Michael
Zulu, Derrick

Preface

One is always grateful to those through whose writings some acquaintance with contemporary African art has been made possible. I have in mind here people in particular such as W. Battiss, B. Hart, E. Berman, L. Watter, L. Goodman, and many others, and periodicals including *Lantern*, *The South African Panorama*, *The Classic*, *Artlook*, etc.

Many persons and institutions have played an important role in contemporary African art in South Africa, often at great personal sacrifice. One need only recall our public and commercial galleries; teachers, such as Cecil Skotnes, Bill Hart, Lorna Peirson, Govenius, and many others. In addition, there are other individuals who have taken an active and sincere interest in our African artists, amongst whom mention must be made of Dr Wolfgang Bodenstein, Madam Haenggi, Mrs L. Goodman, Mr Egon Guenther, etc. Although there are many, many others, space does not permit me to include their names here. The story of contemporary African art can never be recollected without all these people occupying an important place.

This book comes in response to the question whether the time has not arrived for an illustrated volume on contemporary African art. It is conceded that the visual arts can never adequately be appreciated and understood merely from verbal descriptions and photographs. Yet, this is the only way in which millions of people all over the globe have become acquainted with the works of both the great masters and lesser artists.

I have purposely tried not to separate too rigidly artists of merit from so-called "lesser ones". The object of this book is a general one, namely to establish acquaintance with as wide a number of African artists as possible. There are many excellent African artists of whom nothing is heard simply because they do not live near any of our major centres where it is possible for them to exhibit their work; yet their works are as deserving, interesting and lasting, and merit inclusion in a book of this nature.

This volume is not written and compiled by an artist, or even an authority on art, but by an Anthropologist who has a deep interest in, and concern with, the Black man in South Africa. It must, therefore, not be regarded as an authoritative or technical work in any sense. That I leave to those better qualified for the task. It is hoped that, with all its obvious shortcomings, the book will be received in this spirit.

There may be criticism levelled to the effect that this volume gives too much emphasis to content and meaning in contemporary African art. However, as an Anthropologist this is what concerns me most. We all wish to know how our fellow residents in South Africa live and fulfil themselves, especially those who have been blessed with creative ability. We can see in African society and African art, motives and aspirations in which universal values are reflected, and this may condition us to a greater objectivity about ourselves.

I am greatly indebted to Professor Otto Raum who first drew my attention to the beauty and importance of contemporary African art. I must express sincere appreciation to Professor Walter Battiss who has greatly inspired me, and who has taught me to see anew that which surrounds us.

I am very grateful to Mrs E. Berman, Mr Egon Guenther, Mrs L. Goodman, Miss L. Peirson, Dr W. Bodenstein, Mrs H. Eglington, Mrs Phyllis Baillon, Miss Estelle Marais, Miss M. Bull, all of whom have been extremely kind and co-operative. A sincere word of appreciation is given to Gallery 101 (Johannesburg), the Goodman Gallery (Johannesburg), the South African National Gallery (Cape Town), the South African Department of Information (Pretoria), and Howard B. Timmins (Publishers, Cape Town). Without their assistance and co-operation this book would not have been possible. I also thank the many African artists who have so kindly co-operated and gave of their valuable time.

To my colleagues in the Department of African Studies, especially Mr V. Gitywa, and Mr P. D. Banghart, I extend my hearty thanks for all their interest and the trouble taken on my behalf.

I must also express my sincere gratitude to Mrs Janet Smith who so ably typed and proof-read the manuscript, often at great inconvenience to herself.

E. J. DE JAGER

Department of African Studies,
University of Fort Hare, C.P.
July, 1972.

Contemporary African Art in South Africa

1

In referring to contemporary African art it is not the intention to *brand* it as something special and apart from art in general, or as a special type or category of art. It merely refers to contemporary art as created by the African artist in South Africa. Contributions to the contemporary South African art scene come from artists of both European and African origin. We deal here with the contribution of the artists of African origin. We are not, therefore, referring to the *special art* of a group, but rather to the art of a *special group*.

The contribution of the African artist must, therefore, not be seen as differing in some radical way from that of the European artist. It is, however, for various reasons, considered that it warrants separate treatment. So, for example, there is still much more uniformity in the environmental and inspirational sources of the African artist, and these sources still differ widely from those of the European artist since we can never free the artist, and consequently his work, from his cultural background and environmental setting. Without differing radically it may well in future develop into something particular with its own traditions. It already contains much originality, sincerity and power of expression.

By contemporary art is meant art through the use of the accepted western media and techniques, that is, the art of carving and modelling in the round and in relief, painting in oil and water-colour, graphic forms of art, etc.

2

Aesthetic experience and the urge to beautify his environment and the conditions under which he lives, is a universal characteristic of man. No people, society or community is known where this aesthetic need does not exist. In this man is unique since no other living organism has these aspirations.

For more than a century, artists, scholars and collectors have been stirred by the aesthetic qualities of African art forms found in museums and private collections all over the world. These have been studied in great detail, from various points of view. The prehistoric and pre-colonial African art forms are, therefore, relatively well known and understood. By comparison very little attention has been paid to contemporary African art.[1] This is for more than one reason a great pity.

The study of contemporary African art should be very important. It is as much a contribution to our contemporary art scene and as much part of our South African art heritage as that of the European. As such it deserves our attention.

In South Africa, as in all parts of the world, individuals, peoples and race groups are in dire need of a better understanding of each other. Art must of necessity be a very important avenue towards such understanding. Is the essence of a people, their deep reflections on the world and their philosophy of life and hope not portrayed by those fortunate enough to have received the talents to express it creatively? Is the art of a people, be it literature, music or visual, not the portraying of the stresses and strains to which they are subjected, of their achievements and tribulations, of their successes and failures? History has proved this claim to be justified. Through the appreciation of the art of others the individual can innovate himself into the concept of unconditional objectivity so necessary to the understanding of others. It goes still further, it becomes a mirror in which one can recognise one's own image as reflected in others and it can lead to a deeper understanding of oneself.

Contemporary African art is also of academic importance. When two (or more) cultures meet we refer to the situation as one of culture contact or acculturation. The most important characteristic of such a situation is the change that results in the cultures concerned due to the contact. Another characteristic is that this process is always reciprocal, that is, there is mutual influence and change and both cultures are affected. One culture may be in a dominant position, the other mainly in a receiving position. Never, however, can the one culture, even in the dominant position, escape from the influence of the other. In the case of the contact between African cultures and European culture in the field of art, the African has taken over the western media or is employing the old media in new ways. The European artist, on the other hand, has often taken over amongst others, form and motive from African culture. We need only look at some of our prominent South African European artists to realize what a profound influence and enrichment African art

and culture has had on European art in South Africa. It is perhaps this influence of African culture that really sets-off South African art from its European traditions.

The nature and consequences of the cross-cultural influences resulting from the contact situation must of necessity also be reflected in African art. Contemporary African art may therefore be a very important field of analysis of culture contact and change. It may throw valuable light on aspects such as integration, adjustment, adaptation, accommodation, etc. All this is made possible because of the integrative and functional character of culture, i.e. the fact that all aspects of a culture are integrated and interrelated, and change in one aspect must also have influence on other aspects of culture, such as religion, economy, education and political and social structure. Influences and factors operative in these spheres of culture will and must be reflected in art.

3

One often finds the viewpoint expressing concern about the disappearance of the older forms of African art as expression of African aesthetic power; even those who find contemporary African art distasteful in comparison with classic African art, and void of originality, power and expression. One must, however, not take too pessimistic a point of view on this. New African art forms certainly have their merits and values. It is often argued that European influences threaten and corrupt African art. This is not wholly true. The decline of classic African art cannot be ascribed solely to European influence. Classic African art had some inherent weaknesses. Due to centuries of isolation, a certain amount of stagnation was inevitable. It was also subject to certain foreign influences, for example, Islam, before contact with the European. Much of the traditional African art had by that time already degenerated, and inter-tribal warfare and strife were not the least of the factors responsible. Contact with the European may have hastened the process but it would have completed itself in any case. We should not look exclusively on the negative side. Contact with European culture also had its positive advantages. Perhaps the greatest of these is the stimulating challenge brought to the aesthetic ability of the African artist.

Under European guidance new media have been employed to the benefit of African art. These new media mean a much larger variety of ways in which the African artist can express himself. It consequently renders a greater plasticity and possibility for expression. Under the new conditions the really gifted and talented African artist is relieved from all the tribal chores and duties which bound him under the old system. He is now in a position to pay all his attention to the development and maturing of his talents. This is also due to the fact that his art now offers him a means of subsistence and monetary reward. It is often said that African art has become commercialized and there may, to a certain extent, be truth in this claim, but this may happen to all art in all places, especially in our day, where a large number of people have become aware of art and find themselves financially in a position to buy art. The collection of art is no longer a prerogative of the few who are rich and educated, as in the past. Art does not necessarily cease to be art because it is made for monetary gain, or because it is created for a wider audience.

In traditional society it was difficult to distinguish the true artist from the craftsman. Now the true artist is no longer subject to the rules and norms which guided the craft-orientated creative processes of traditional society. By the same token the changed circumstances also free the African artist from the traditional group-orientated thought processes of his traditional society. He consequently becomes an individual who can express his own thoughts, as and when they are given birth during his new life experiences. This leaves him more room for originality, innovation and experimentation. It presents a challenge to create a new tradition.

The time has come to stop regarding the African artist as a childish and docile imitator of the European. In the realm of art the African artist has, without doubt, proved sufficiently that this is not the case. The application of European media does not necessarily mean that the result must be a kind of imitation art. African art of the past, and this applies equally to the present, shows enough genius and vitality to develop into something splendid, original and forceful. Undoubtedly there are at present certain strains and inhibitions, but these must be expected during a

transitional stage, such as this. It is often claimed that the town and city-bred African is without an anchor in life because of the loss of traditional values. This, however, is not all that there is to the situation. It should be borne in mind at the same time that we have second and third generation African dwellers of the town and city who have succeeded in replacing traditional values with new ones. It does not follow that a vacuum exists to the extent that is often claimed by so many. African artistic productivity is gaining momentum and, from present indications, can certainly look towards a bright future.

4

The study of contemporary African art must be based on the acceptance that there are many divergences from the traditional or classic forms. This does not mean, however, that it is unrelated. An analysis of contemporary African art will also show many continuations of traditional influences and characteristics. In a sense the African artist is fortunate in that he finds himself as part of two worlds, two traditions and two heritages. This gives him the opportunity to select the best from both, and to combine them into something unique. There need be no fear that this will not be something 'essentially African'. It will undoubtedly be *African*, be it of the new Africa. One is tempted here to think of the words of the eminent Negro poet, philosopher and statesmen, Leopold Sedar Senghor[2]:" . . . the neo-African . . . intends to contribute doubly to the Civilization of the Universal; to the civilization of the 20th century. Firstly, by contributing the riches of his traditional philosophy, literature and art; and secondly, by showing the borrowings he has made since the Renaissance from other civilizations, particularly the European . . ." Art has always been the expression of a particular conception of the world and life. In essence it is the supreme expression of an ontology, a *weltanschauung*, be it that of an individual or society, or the two in relation to one another. Contemporary African art will in many ways and amongst others also be such an expression. What exactly it will express cannot be determined at this stage. It will obviously differ in important ways from the old, and it is, as yet, incomplete. If this *Neo-africanism, Negritude*, or call it what we will, is what

arises from the experience of the African, we must accept it as real, and we must appreciate it as such. We cannot expect the African to remain static in philosophy and art; we do not want him to become an imitation of the European philosopher and artist. Fortunately there are many indications that neither will happen, but rather that the African philosopher and artist of the present and future have something to say to us, something new and enduring, something born of his experience and his deep reflections on life and being. There should be no doubt that this will be of universal value and a contribution to civilization. Very often this Neo-africanism or Negritude is regarded as dangerous, degrading and unwanted. It is, however, none of these things provided that it is not abused. Any system of values when abused is dangerous and undesirable. The possibility also exists that there might be those who will apply this Neo-africanism to their own selfish ends and personal aspirations. This possibility and danger exists, however, for all systems and philosophies. The essence of Neo-africanism is perhaps expressed clearly in words of Senghor[3]:" "...it is rooting oneself in oneself, and self-confirmation: confirmation of one's being", and "Who would deny that Africans too, have a certain way of conceiving life and living it? A certain way of speaking, singing and dancing: of painting and sculpturing, and even laughing and crying?"

5

The historical background of African art, against which, to a certain extent, contemporary African art must be seen, cannot be discussed here. Rather would one prefer to jot down some thoughts based on a viewing and evaluation of contemporary African art. It needs to be pointed out first, however that traditionally the African of Southern Africa does not have, by comparison, the great art heritage and traditions of the people farther to the north of the continent. The little artistic skill that did exist was limited mainly to wall decorations and their crafts such as beadwork, weaving, etc. Nevertheless, the contemporary African artist does have an innate and inherent artistic ability, and perhaps some impulse which has remained dormant over the centuries. As his contact widens the African artist in South Africa will undoubtedly take note of the great art

traditions of Africa, and little doubt can exist that he will have the ability to interpret it and to find some association with it.

One is immediately struck by the idiom used by the majority of contemporary African artists in South Africa. It is realised that it is dangerous to pinpoint any one particular type of style since, for example, it is known that more than a thousand style variations are known from traditional African art. Apart from a few of the older African artists, to whom reference is made at a later stage, the majority of contemporary African artists work in an idiom which can be described as *figurative expressionism.* It is dangerous to over-generalize this point, but a definite tendency away from the nuances of naturalistic expressions and forms can be discerned. This is logical in view of the fact that naturalism has never been a significant characteristic of African art. Many modern artistic forms brought about in Europe by the revolution in art during the previous century were foreshadowed, in a way, by classic African art. Undoubtedly one can say that classic African art was an important influence in bringing this revolution about. The tendency away from naturalism towards figurative expressionism can also be explained and understood in terms of the African's nature and disposition. This again can be related directly to the African philosophy of being. Tempels,[4] and others, have clearly illustrated that the essence of African ontology is that 'being is force', and he calls it 'the principle of activity'. African art, being an expression of this particular way of seeing a world of life forces, is of necessity not interested in naturalistic realism, an imitation of the object, even be it a corrected or idealised imitation. It is more interested in portraying the dynamic vitality of the life forces present in the Universe. This philosophy of notion or being can be expressed *par excellence* by the nuances of modern art.

Obviously the traditional philosophy or notion of being, due to the contact with European culture, will undergo changes. It can, however, be stated with a reasonable measure of certainty that it will not lose its essence and vitality, and that it will remain the message which the African artist tries to portray in the created form. Again I think the time has come to accept the fact that the African will not, and cannot, subscribe totally to European philosophies, unrelated to his past and ex-

perience. His philosophy must be that out of which he grew and developed, related to his unique experience and ways of seeing the world and life. This will illustrate the enormous plasticity of human nature and experience. It will not, and cannot be inferior to European philosophies, and time will show it to be a unique contribution to human intellectual experience and achievement. Those who believe that this 'African philosophy' must be inferior to Western forms, and unfortunately there are many Africans who subscribe to this view, cannot but be biased and their evaluation subjective. Who can call a peoples' experience inferior? What are the objective criteria for determining this? It must be real, and how can something real be judged inferior merely because it is different or unusual from the accepted, or that to which one is accustomed?

When viewing African art, one is also struck by the African artist's *preoccupation with man.* In his opening address of the *Fort Hare Jubilee Art Exhibition* in 1966, Professor O. F. Raum[5] expressed himself as follows:

"One of the most noticeable qualities, surely, is that the main concern of the artist is with man. Pictures of landscapes and sculptures of animals are few indeed, and scenes of daily life a poor second to statues and portraits. Are we wrong if we interpret this almost exclusive preference for the topic Man as an indication that in their work the artists try to answer the question: What is man? How does the nature, the essence of man become intelligible through the created form? And the African artist's answer is plain to see. The essence of man, the very nature of man, reveals itself in his emotions".

The African artist's representation of man shows an infinite variety of human emotions: love, sorrow, joy, disappointment, anxiety, adoration, desperation, rejection, etc. It is through powerful expression in colour, distortion of form and unusual perspective, as Raum rightly points out, that they convey their message, *the essential of man as reflected by his emotions.* It indicates the African artist's knowledge and awareness of human nature and experience, of man's aspirations, shortcomings and hopes. Very few contemporary African artists have really had any profound formal training. To many of them life was their only teacher. Their art, without any doubt, indicates that they are intensely committed to partaking of and observing life.

It would be dishonest not to state that, in the case of the majority of contemporary African artists, their work is technically still far from perfect. One cannot, however, escape their innate urge to express and interpret human experience, which endows their work with a moving message.

The viewer of contemporary African art is also impressed by the fact that the artists occupy themselves almost exclusively with the African. They seldom attempt to portray experiences and life of persons from other race and culture groups. His people, himself, and the conditions and experiences of their lives is what the African artist busies himself with. The dignity of the African matron, the beauty of the African face and figure, the humour of African life, the African's day-to-day plight, the African's deep-rooted faith, African sensitivity – these are the subjects portrayed. The African artist does not attempt to understand the world and experience of other peoples. His message is the endless and subtle variety and spice of life as experienced by the African. It is this, perhaps, that renders their art so sincere, moving and minute in detail. Because of the African artist's preoccupation with his own people, their life and their destiny, his art is still very much designated *'expressive culture'* in the same sense as religion, mythology, etc.

The preoccupation with his own people is indicative of the fact that the African artist is aware, consciously or subconsciously, that art really flourishes and prospers when related to what is one's own. Art is not only the creation of an individual but, to a large extent, the expression of the collective spirit and feeling of a people or group of people united by common ties, thus the interaction between artist and group. In spite of the fact that it is believed in certain art circles that art has an independent existence, and this may even be so, the fact remains that through all ages, in all places, the highest manifestations of art have always been culture bound. Because art is culture bound it does not mean that it cannot express the universal or the most personal of experiences. It simply means expressing it in terms of that with which the artist is intimately acquainted.

Art is also closely connected with the experiences of the people from whom it originates. For this very reason we find a much greater variety of themes and motives in European art than in African art. In a sense the African artist's contact with the world is more limited than that of the European since it is not so long ago that African societies were brought, for the first time, into contact with the outside world. The scope of the experiences of African peoples must, therefore, be more limited and this is an important reason why the contemporary African artist is still mainly concerned with the African world. As they progress in time and experience their art will no doubt broaden and deepen in scope.

Meaning in art may be both overt and covert and thus represent actual activities, or, it may have a connotated wish fulfilment, etc. In the latter cases the meaning is not so obvious. Europeans often cannot know the symbolic expressions of contemporary African art because they live outside the society and way of life of these artists and their people. To the European much of their art may therefore appear esoteric. The contemporary African artist is evolving an interesting symbolism around his urban way of life and circumstances. This applies especially to the meaning and content of their art.

Unfortunately at this stage the African artist's audience is still mainly European clientele and not his own people and society. We know, therefore, very little of the reaction of their own society to the contemporary African artist's aesthetic experience and expression. Surely it is necessary that an artist also knows the feeling of his own people towards his art! Prices are of course seldom geared to the more average income of the potential African buyer. African artists will have to realize that they have to set their prices lower, even if just for the African buyer, to enable their own people also to afford their work. It is important that African artists also know and satisfy the aesthetic needs of their own people and society; only then will their art become even more rooted in their own.

6

It is the intention here to give only a very brief introduction to some of our African artists. No offence is meant to any artist by omitting reference to his work. The notes on artists and their work may, in some cases, be incomplete in many details because of the difficulty of contacting the individual artists,

and the paucity of information regarding their work.

All in all, emphasis is still much on content and meaning in the painting, drawing and graphic work of South African Black artists. One notices especially two important major sources or themes in this field of their art.

Some of our African artists draw very heavily on tradition, custom, folklore, etc. and go back to traditional African culture and values as a source of inspiration. However, in most cases it is not a *per se* portrayal of these matters. Most artists adapt this source to their own views and experiences and render it in a very personal manner. Consequently we find much individual originality and variety in the interpretation of this source. The element of mysticism in the use of traditional and tribal, ritual, folklore and mythology is important in the interpretation of these sources. The symbolic, narrative, lyric and allegoric qualities of traditional culture and values are often incorporated to form a syncretical or even original synthesis between the old and the new, past and present.

The other important source or theme is the daily life of the African as experienced in our cities and towns. The generic term *'township art'* has come into use to indicate this. Many people regard this so-called township art with scepticism and perhaps they are, in some cases, to some extent, justified. It cannot be denied that bad township art does exist. However, the observer should not take too superficial a view of so-called township art. Very often on closer analysis it can be discovered that much of this work is far more penetrating than what the general term, township art, suggests. We must also bear in mind that in township art we deal with both 'social situations and social images' (so far as the human condition is social) and 'social identity'. The situation or image is township life and consequently universal, whereas the identity is African as experienced locally. These two elements must be seen in proper relation in order to maintain the correct perspective. A large number of African artists show through their township art the universal dilemma of industrialization, urban life and the associated values. They express this in terms of African identity and that with which they are intimately acquainted. It cannot be denied that township life is a real experience for most African artists, that they feel concern

about its hardships, and that they want to portray it as a reflection of the life of their people. In this sense they have elevated township art to the level of a very expressive 'idiom', sensitive, revealing and powerful in its socio-cultural and aesthetic impact. Some artists use it as social satire and criticism; others use it to express indignation, often with violent emotional overtones. To many it has become a safety valve for their own emotional life. Still others feel it as a penetrating personal experience. Many can overlook the dark side and also see young people in love, people going about their daily tasks, children running errands or playing in the streets, etc. There is almost no mood or aspect of township life not reflected. One of the supreme merits of township art is that there is no conflict between communication and technique, these elements have not become separated as with so much modern painting. Township art still adheres to the historic role of art as communication, it can reach and move men because it is not alienated from South African society, in which it is rooted. Township art has not developed an awesome technical and intellectual power that cannot communicate with the common man, its creative motivation derives from communicative rather than technological considerations. It carries in itself its complete significance, it has what Matisse has on occasion called "instinct". As such it explodes through all barriers of time, place and race; it becomes a visual narrative of urban life and its ramifications, it comments on the social order of our time, the human dilemma which faces us all, our inability to live with ourselves and our fellowmen. Township art invites us to partake, and as such it has a deep and sincere purpose — think, reflect, search your conscience, feel and then know; ultimately it is a search for truth. Because of the inherent and significant meaning and content the technical aspect of township art is reinforced and gains in integrity, so that much of township art can stand and survive on purely aesthetic grounds. Township art is an important social document that can be studied with great benefit by Anthropologists, Sociologists, and others.

A third minor theme is perhaps the African artist's interpretation of Biblical and Christian themes. Here also we find very personal interpretations displaying a variety of qualities and aspects.

Berman[6] correctly points out that during the late fifties of this century an entirely new phenomenon appeared on the South African art scene, namely the emergence of African artists with work that can be characterised as *humanistic figurative expressionism*. This is still the dominant idiom in which our African artists work. Battiss[7] referred to it as a "new African art" in South Africa.

Prior to the emergence of this new African art there were only isolated examples of African artists being seriously involved with art in the modern idiom. The more important of these include: Gerald Sekoto, G. M. Pemba, Gerard Bhengu and Selby Mvusi.

G. Sekoto[8] is perhaps the best known example of these early African artists. He has, however, spent the greater part of his career in Paris, France. Although he has developed considerably during his career the most notable overall qualities of his work remain the way in which he uses colour, his unconventional viewpoint, and the way he handles forms through distortion and perspective. His subject-matter has remained to a large degree African life, but due to his absence in Paris, it acquired an idealized quality. His work was also influenced to an extent by his Paris environment, and a loss of precise memory of Africa and his source of origin.

Ranking in seniority with Sekoto is *G. M. Pemba,* who for some reason never became very well-known outside the Eastern Province. He is entirely self-trained and his media water-colours and oil. His work is characterized by a certain formalized academic quality. He is in the first place a painter of portraits, but he also paints people in different and varying moods. His work contains always a spark of humour and a sensitive and sympathetic awareness of other human emotional qualities. He never ventures far from the daily life of the African people, both in the township and rural frame of reference. He has remarkable insight into the moods and feelings of his people. He also occasionally draws from folklore. He has an accomplished style, and his work is always pleasant to look at. A sure hand and a measure of confidence is evident in his paintings, undoubtedly due to the fact that he is a competent draughtsman and because he always paints within his own metier. There has been some development in his style from the naturalism (perhaps resulting from his being an illustrator of books) of his early water-colours to the limited expressionism of his later oil paintings. He has also become bolder in the use of colour. Sincerity is an outstanding characteristic of his art.

Also dating from the pre-fifties period is the Zulu artist, *G. Bhengu.*[9] Born in 1910 in the southern part of Natal, he started his education at the Roman Catholic Mission of Esibomvuini and later attended the Edenvale Training College. This amazing artist, who now suffers from ill-health, works mainly in pencil and sepia. His character studies and portraits, mostly taken from life, have an almost photographic quality so precise the detail. His style is completely unspoiled by the influence of any contemporary trends in art. His intimate knowledge of the Zulu people is portrayed with accuracy and sensitive insight. Although wrongly never regarded highly in art circles, his work today demands good prices, if and when available.

Although he spent the greater part of his creative career in the United States of America, West and East Africa, *Selby Mvusi* must be included here as he also belonged to the pre-fifties group of African artists from South Africa. He was concerned with African urban life and, in addition, produced a number of works interpreting Biblical themes. He worked mainly in pencil and chalks, and possessed a strongly developed style and technique, very suitable for drawing. Mvusi, who was educated in South Africa, was also an arts graduate from Boston University, and taught in West and East Africa before his death.

Somewhat of a rarity is the scintillating personality and work of *Gladys Mgudlandlu.*[10] She was born in 1925 in the district of Peddie in the Ciskei. At the age of twelve she went to Port Elizabeth for her primary school education, thereafter attaining Standard VIII at the Healdtown Institution, and the Teacher's Diploma at Lovedale College, near Alice in the Eastern Province. She teaches art at the Athlone Bantu Community School in Cape Town. This artist started painting seriously round about 1952, and received some guidance from Katrine Harris, although she is largely self-taught. She loves nothing more than to see the reaction of people to her art. For inspiration she draws heavily on the folktales of her people as related to her by her grandmother. She endows these with a form and content in which her own vivid imagination plays

no small part. Perhaps the most outstanding characteristics of her work are the uninhibited use of colour, the unusual perspective (she invariably shows her subjects and topics from a high focal point), and the spontaneous and simple qualities of her technique and style. Her work is attractive and one cannot help but enjoy it. Much of its charm lies in the fact that technically it is far from perfect and, therefore, is so very spontaneous. She had her first two major exhibitions in Cape Town, and has since exhibited widely in the Republic and abroad. In 1963 she won a prize in the *Art South Africa Today Exhibition*.

Eric Ngcobo was born in Zululand in 1933, where his father was a teacher at the royal kraal of Prince Mshiylni at Dlamalahla. He obtained his secondary education at Inkamane and in 1953 proceeded to the Indaleni Art School. After teaching in Glencoe he became the successor to Selby Mvusi at Loram's Secondary School in Durban. He later moved to Kwa Mashu, where he is still teaching today. Ngcobo is both a painter and sculptor. In painting his medium is mainly oil. He draws his inspiration from a wide range of sources including tribal folklore and urban life. In his early work he used vivid colours, and there is some element of mysticism in most of his work. In 1961, he was awarded a gold medal at the *Republic Day Art Exhibition* in Bloemfontein. He was the first African Artist to hold a one-man show in the Durban Art Gallery. His work is contained in many private collections in South Africa and abroad.

South Africa is unfortunate in that it lost a number of very promising and talented African artists in the early years of their lives. These include Andrew Motjuoadi, Julian Motau, and Ephraim Ngatane.

Andrew Motjuoadi [11] was born at Pietersburg in 1935, but very little is known about his early life apart from the fact that he attained a high standard of education at various places in Durban and at the University of the North. Subsequent to a stroke in 1967, he died in November, 1968, at the age of thirty-three years. His main source of inspiration was township life with which he appeared to be well acquainted. He was self-taught, and is known in particular for his excellent pencil drawings. He had a naive and almost primitive portrayal of his subjects, and his work is endowed with considerable atmosphere and philosophic speculation

about man. He is always in great sympathy with the subjects portrayed. His work is characterized by immense detail and very neat patterning. This, together with the handling of texture and form, gave a particular individual quality to his work. In 1966, his work was included in the London Piccadilly Gallery's *African Art Exhibition,* and he was also awarded a prize in the 1966 *Artists of Fame and Promise Exhibition*. Had Motjuoadi lived he would, without doubt, have become one of our most accomplished African artists.

The death of *Julian Motau,* who was shot and killed on the night of 17th February, 1968, whilst visiting friends in Alexandra Township, came as a shock to the country for here was a really promising and talented young artist. Mrs Linda Goodman gave Motau his first opportunity of studying and exhibiting, and arranged exhibitions of his work in Israel and the United Kingdom. He was to have had his first one-man show in Pretoria on 26th February, 1968, and this — tragically enough — had to take the form of a Memorial Exhibition to the young artist. [12] His paintings, mainly about township life and experiences, show a remarkable sensitivity and in many of them one can almost experience the agony, devotion, or whatever emotion he was portraying. His drawings are exceptional in respect of the insight they display into human feelings and emotion. Consequently his drawings have great atmosphere, and one often gets the impression that what Motau really was portraying were human emotional qualities and not so much the realism of the circumstances of his subjects. His work is also characterised by an outstanding sense of composition. Most of his canvases are completely filled, but it is the emotional quality of his work which spills over, never the technical composition. Had his art been able to evolve, it would have displayed a unique degree of inventiveness, already present in his early works.

Ephraim Ngatane, [13] who died in 1970, was another sad loss. He was born in Lesotho in 1938. He studied for a number of years under Cecil Skotnes at the Polly Street Art Centre in Johannesburg, and under Duncan Hall, an American missionary in Johannesburg. He worked mainly in water-colour and gouache. He had a good command and control of these fluid mediums. He later also worked in oils. He was sensitive to township life and his work displays perceptive drawing

of intimate and unglamourized township qualities and emotions. He enjoyed a large support throughout his life, and had a number of very successful one-man exhibitions. In 1966, he was included in the *African Art Exhibition* at the Piccadilly Gallery in London. His work was also represented in the *Republican Festival Exhibition* in 1966.

One of the most interesting of the younger generation of African artists in this country is *Azaria Mbatha*,[14] who was born in Zululand in 1941. He left Ceza Secondary School in 1961 to work as a clerk in Vryheid, Natal. After contracting tuberculosis, he was sent to the Ceza Mission Hospital, where he met Govenius who stimulated his interest in art. When Govenius was asked in 1961 to establish an art school for Africans Mbatha moved to Umpumulo in Natal, as a full-time student. In 1963 the art school moved to Rorke's Drift, where Mbatha is still teaching today. In 1966 he was awarded a scholarship to study at the Konst Fack Art School in Stockholm, Sweden. His medium is graphic. Initially he worked in linocuts and murals, but lately he has included silkscreen prints and copper etchings. A number of his linocuts have been interpreted into murals and tapestries, the latter often being done by his wife. In his early work Mbatha was undoubtedly greatly stimulated by the discussions on theological matters by theological students at Umpumulo, with whom he came into contact. From this time dates his personal interpretations of Biblical stories and motives, which are considered by many to be his best work. These early linocuts have a Romanesque quality, and they are narrative in nature. His later works draw more heavily on tradition and folklore but they also display qualities of the subconscious. Mbatha has made the medium of linocut indisputably his own, and his style, especially in his early works, is well developed. All in all, he is a remarkable artist. In 1965 he was awarded a prize in the *Art South Africa Today Exibition*. The following year his work was included at the *Republican Festival Exhibition*, and he has since had many exhibitions. His work has been acquired by a number of galleries in South Africa, various institutions in Sweden, and the Museum of Modern Art in New York. In addition it is contained in numerous private collections in South Africa and abroad.

Winston Saoli[15] was born in 1950 at Acornhoek in the Eastern Transvaal. He attended the Arthurseat Lower Primary School and later, after his family moved to Johannesburg, the Morris Isaacson School in Moroka. He was greatly inspired and encouraged by Ngatane, Legae, Skotnes, and Hart. He is both a sculptor and painter, but is mainly known for the latter. His media consist mainly of duplication inks and sepia chalks, and he employs both brush and his fingers to obtain the effects required. His work displays great creative spontaneity and his style a great sensitivity. He is said to be involved in form rather than content, and that he does not use townships and their environment to convey poverty and hardships but rather as a means to promote compositional elements. He had his first one-man exhibition in Johannesburg in 1969, and also had his work exhibited at the *Contemporary African Art Exhibition* at Camden Arts Centre in London.

Louis Maqhubela has proved himself to be an artist of unusual talent. He was born in 1939 in Durban and went to school in Johannesburg where he received his secondary education at Orlando High School. He studied for some time at the Polly Street Centre under Cecil Skotnes and also received guidance from G. Cattaneo. Maqhubela has on several occasions visited Europe where he met Sekoto, and was greatly impressed by Douglas Portway. Maqhubela's art has shown remarkable and prodigious progress and development from the naive amateur skill which had first attracted attention to his present-day professional accomplishment, and this has been possible mainly because he set himself the discipline of developing his draughtmanship and strengthening his pictorial forms.[16] In his early works figurative emphasis was still explicit but his later work has been described as poetically conceived images in which shapes extend and relate across the picture-plane, where form appears to dissolve and then is re-established by the flick of a line or by a touch of texture.[17] Maqhubela's superb sense of colour is a distinguishing feature of all his later canvases. Today his work is thoughtful and abstract[18] and clearly derives from mystical and deep philosophic meditation, resulting in an intense symbolism and containing a unique poetic power and quality. His work has great imaginative power and vision. Maqhubela has succeeded in sufficiently separating his existence as a member of a group from his art. Through this he is

able to transcend his immediate life and enter completely into artistic endeavour and experience. Consequently he has attained a level of maturity and individuation, which has put him on the road to being a great and outstanding artist. Without doubt, he has developed his own artistic identity. The future will prove Maqhubela to be an important innovator in African art in South Africa, and to be a pioneer in giving it new incentive, impetus and direction which will lift it to an even higher level of achievement and maturity. In 1966 he won first prize at the *Artists of Fame and Promise Exhibition*. He had his first one-man exhibition in Johannesburg in 1967, and also exhibited at Piccadilly Gallery, London. In 1969 he won the Cambridge Shirt Award in the *Art South Africa Today Exhibition*, as well as exhibiting at the *Contemporary African Art Exhibition* (Camden Arts Centre) in London.

Mslaba Dumile must surely be regarded as one of the artistic geniuses to be produced by Africa in our time. He was born in 1942 in Worcester in the Cape Province of devoted Christian parents. Upon the death of his mother in 1948, the family moved to Cape Town. At eleven years of age he went to Johannesburg to live with an uncle's family. His artistic skill was first noticed in 1964 when he was treated for tuberculosis in the SANTA Hospital in Johannesburg. In 1965, he was sponsored by Gallery 101 in Johannesburg and in 1966 he had his first one-man exhibition. He left South Africa in 1968 for Europe and has never returned. Dumile is both sculptor and graphic artist (mainly drawing) but he is best known for the latter. He is often referred to as "the angry young man". The content of most his work deals with the social position and the problems of identity for the African in township and urban life. His drawings have been described as intense and passionate, highly personalized outpourings of his unsheltered experience.[19] His work tends to display morbid undertones and is characterized by contortion and distortion which often erupts into violent emotion, and powerful protest and indignation. It has a vitality which Dumile seems to draw from the subconscious realms of his mind. In a number of his drawings Dumile consequently displays strong subconscious tendencies. These drawings are free from the exercise of reason and aesthetic pre-occupation. One gets the impression that Dumile creates according to the dictates of his subconscious mind and vision. Figures are distorted, they border on the fantastic, and are in unexpected juxtaposition and reminiscent of hallucinatory experience. There is a subconscious strangeness in these drawings, as if they are not portrayals of human emotions on the controlled manifested level, but of the strange instincts and emotions which dwell in the human subconscious. Yet these drawings should never be interpreted as nihilistic. They do not denote only scepticism and satire which would involve a total denial of all existence, the drawings have a far more significant purpose. They are productive communication. It was the poet Horace who once advised the artist "if you want me to weep, you must first grieve". Dumile in his drawings grieves and generates feeling and emotion. As such his drawings are of profound significance and images of human life and suffering, almost metaphysical outpourings of the subconscious. Perhaps the all-pervading theme of his art is the tragedy of man. His art has that particular quality which attracts the viewer to assess and reassess, time and again. Technically, Dumile's drawing is far from perfect. However, its spontaneity and the passion and conviction with which it is done is obvious and almost overwhelming. The drawings bear witness to the urgency, vitality and tension that went into their creation; they are the expression of emotions being painted. Dumile has had a number of one-man exhibitions in South Africa, has won a number of prizes and represented South Africa at the *Sao Paulo Bienalle* in 1967. He exhibited at the *Transvaal Academy in 1965*, and at the *Republican Arts Festival* in 1966. He also exhibited at the Grosvenor Gallery, London, in 1968, and in 1969 at the *Contemporary African Art Exhibition* in London. His work is contained in many private and public collections in South Africa as well as overseas.

Dan Rakgoathe exhibited professionally for the first time in 1967. He has since exhibited in the *Contemporary African Art Exhibition* run by the London Art Centre (Camden), as well as an exhibition of African Art by the University of California, Los Angeles. Rakgoathe is a graphic artist and his work contains some excellent qualities, notably in composition and form. It displays a sense of mysticism, and he is very much involved with the tragic and mythological.

Cypian Shilakoe was born on the 3rd August, 1946, and grew up on a lonely mission station at Buchbeeskreich. He spent most of his life with his grandmother until her death in 1962. In 1968, he went to Rorke's Drift and has since participated in a number of shows in South Africa, Sweden, Denmark, Germany and Italy. He is much involved with the tragedy of township life, around which he has built a considerable symbolism. Yet, his work is more than a local manifestation of, or identification with, urbanization, for it reaches out towards the universal dilemma of this phenomenon, and the special and particular problems and questions raised by this. A large number of his works are, however, locally situated, and a satirical and social comment on the African's life in South Africa. In many of his works he also fuses, very successfully, elements from the past way of life of the African with those of the modern. One sincerely hopes that Shilakoe's art will evolve because he undoubtedly has an important contribution to make. His medium has, up to now, been mainly etching and linocut and, in addition, he does sculpturing.*

John Muafangejo, an artist from South West Africa, is known for his very interesting linocuts. He uses in a most attractive way some of the South West African tribal masks, and his work is highly decorative. He does work of a narrative nature in which he employs direct writing to reinforce his pictorial stories. His style is simple, spontaneous, and completely unaffected. He represented South Africa at the 1971 *Sao Paulo Bienalle.*

Apart from those already mentioned, the following African artists have done graphic work of high merit: *Sydney Kumalo, Benjamin Macala, Lucas Sithole,* and *Ezrom Legae.* Their major contribution, however, has been in the field of sculpture. The artists referred to and discussed above are by no means the only representatives of Contemporary African painting and graphic art forms. To this list may be added the names of *L. Matsoso, Eric Mbatha, Ravie Matshaba, E. Tshabalala, David Mbele, J. Maseko, G. Ndaba,* and many others. The artists discussed show the type of work being done, the circumstances from which these African artists often arise, what they want to tell us in the

created form, what they have achieved, and other similar matters.

We may now turn our attention to African artists' achievement in the field of sculpture. It was the sculptors amongst African artists who were the first to establish a truly professional image, notably Sydney Kumalo and Michael Zondi.[20]

Sydney Kumalo was born in Johannesburg in 1935, and consequently comes from an urbanized environment. He was educated at the Madibane High School. His basic training he received at the Polly Street Centre to which he went in 1952. He was guided and greatly encouraged by Cecil Skotnes and Edoardo Villa. In 1960 he was appointed as art instructor at the Polly Street Centre. When Skotnes resigned, he took over the senior position which he held for four years until such time as he was able to concentrate full-time on his own art. Kumalo is married and has three children. Watter,[21] in her excellent assessment of his sculpture, points out that his work is largely self-explanatory and the impact immediate on the observer. She finds his success lies in his capacity to fuse aspects of two different styles into a new synthesis, namely, forms evolved by traditional African sculpture and amalgamated with the crystallized gestures that were developed out of medieval European sculpture by the Expressionists. He adds dynamic rhythms which break through the static tribal integument, reaching out into sophisticated notions derived from urban consciousness. Watter goes on to state that he consequently appears to stand at the interstices of two cultures. She states that he gives particular attention in his sculpture to the three-dimensional quality of the planes and contours in space to which his medium *terra cotta* is very suited. When the piece is dry he works further on it until the most tenuous spatial tensions are reached between the subtle, asymmetric forms and after casting into bronze, the cast is treated with dark patina. Two themes have pre-occupied Kumalo, namely, the human figure and the beast, and Watter tells us that in Kumalo's later work they inter-penetrate so that the images become manlike beasts. Kumalo held his first one-man exhibition under Egon Guenther's aegis in 1962, as well as his second and third respectively in 1966 and 1967. His work was represented in the 1966 *Venice Bienalle* and the 1967 *Sao Paulo Bienalle.* He

* Since going to the press it has been learnt that Shilakoe was tragically killed in a motor accident in Sept. 1972.

exhibited at the *Contemporary African Art Exhibition* (Camden Arts Centre, London) in 1969. His sculpture has gained international recognition and he has also participated in exhibitions in Italy and the United States of America. His work is contained in many private and public collections in South Africa as well as abroad. Kumalo has been an important influence on younger African sculptors.

Michael Zondi[22] was born on the 10th March, 1926 in the Greytown district, Natal. He spent his childhood at Emtulwa, a Swedish Lutheran Mission near New Hanover, Natal. He was educated at various schools in the Natal midlands, including Dundee. From 1945 to 1949 he ran his own carpentry shop at Edenvale. During this time, at the age of twenty-five, he started wood-carving, which is still his chief medium. He has continued to enlarge his knowledge, with remarkable perseverance, through private study in many fields. From 1956 to 1961 he served as instructor at the Edenvale Vocational Training School. In 1961 he left Edenvale and made a venture into architecture by designing and executing the beautiful chapel at the Appelsbosch Mission Hospital in Natal. He was estate manager at Appelsbosch Mission Hospital from 1963 to 1965. Zondi is married and has six children. He still resides in Natal today. As he never received any art training Zondi spontaneously developed his own very personal and sincere style, for which his medium, woodcarving, is most suited. Though various people encouraged him, his real teacher was life, of which he is an intensely committed observer and partaker. The motivating force of his creativity arises from an innate urge to express and interpret human experience and life through the human form. Thus, almost exclusively, his subjects are the human face and figure. His approach pivots on two major factors: his profound love for his fellowman in his day-to-day plight, and his never faltering belief and respect for the dignity of all human beings. Consequently, his work is endowed with a simple but deeply moving message. Technically, Zondi is uncomplicated with a direct but well-developed style. In 1961 he won a bronze medal at the *Republic Day Art Exhibition*. In 1962 his work was represented at an Exhibition of African Artists in the Durban Art Gallery. He scored two successes in *Art South Africa Today Exhibitions*: in 1963 he won third prize in the

sculpture section, and in 1965, second prize. He had his first one-man exhibition in the Durban Art Gallery in 1965. In 1966, Zondi represented South Africa at the *Venice Bienalle.* His work is contained in many private and public collections in South Africa, the United States of America, Canada, the United Kingdom, Sweden, Germany and Holland. He has carved crucifixes for several churches in Sweden and South Africa, amongst them a life-sized crucifix in Blackwood for the Hospital Chapel at Appelsbosch, Natal.

Lucas Sithole is the product of urbanized society, and the son of a Zionist minister. He was born and still lives in the Township of Kwa Thema, Springs, in the Transvaal. He spent a year training under Cecil Skotnes. His favourite materials include hardwood, stone and liquid steel. Sithole is a sculptor of great talent and his work is in complete harmony with Africa. His work is indicative of the greatness which the new "African art" will attain. There is no trace of European influence and tradition, and his sculpture is indigenous both in form and concept. He has a creative imagination that is entirely his own, both technically and spiritually. His subjects are his fellowman and wild creatures conceived in unusual form with vibrant vitality. His figurative sculptures are especially African in concept, and they are characterized by simplicity of form and a high degree of sensitivity. They capture the all-pervading importance and significance of ritual in Africa. They are ritualistic expressions or *gestalten* of the sacred aura which surrounds African ritual. One is continually aware, while viewing these figurative sculptures, that the visual is involved and that Sithole wants us to "see" more than the immediate appearance, namely that he is portraying qualities in which the sum of the sculpture is far more than the parts of which it consists. Consequently there is much integration, both in form and concept in these figurative sculptures. When seen collectively, they become a vocabulary of moods and qualities with which Sithole establishes real communication. Sithole has had numerous exhibitions of his work in South Africa, and it is represented in many private and public collections here and abroad. He represented South Africa at the 1968 *Venice Bienalle.*

Ezrom Legae was born in 1938. He studied for some time at the Polly Street Centre under Cecil Skotnes and Sydney Kumalo. He became an instructor at the Centre

in 1965. He now works as a full-time sculptor in his studio, and resides with his family in Soweto, near Johannesburg. Most of Legae's sculpture is monumental in concept with strong, yet sinuous proportioning, wide and vibrant planes and surfaces, and intriguing angles. These technical aspects of his sculpture leave the impression that they are not only contributing towards the portrayal of an object or figure but also to a process and urge — namely, the transformation of a material into something meaningful. Legae's sculpture consequently has a strong intellectual quality and appeal, a serious concept of form. His work is mostly conceived fully in the round and one is meant to take a variety of views. His sculpture contains qualities of strength, tension, poise and inventiveness, and they beg enlargement. Legae's imagination shows up clearly in his sculpture, not as vapid day-dreaming, but as a vital experience taking a meaningful direction. His sculptures thus express a great individual creative power which, at the same time, is articulate and manifested. Legae has held one-man exhibitions in various South African cities, and his work is represented in many private and public collections. In 1967 he won the sculpture prize in the *Art South Africa Today Exhibition*. In addition, he has twice received honorary mention for his sculpture at the *Transvaal Art Academy*.

Solomon Sedibane, the Pedi Sculptor, was born in 1933. He received his art education at the Hebron Training Institution, Pretoria. He has a sensitive personality which is revealed in his sculpture and which is rendered in a very personal manner. His wood-carvings are meticulous in detail, in many cases reminiscent of classic sculpture, and endowed with a moving human quality. He portrays emotions through the human face and figure with remarkable sensitivity. He is technically well developed and tends to be naturalistic in his portrayals. In 1961 he received an important commission from the Department of Bantu Education for six sculptures. He has exhibited in Pretoria, Maseru, Durban, Cape Town and Johannesburg. His work has been included in a number of exhibitions, including the *Republic Festival, South African Breweries, South African Association of Arts,* etc. In 1964, he also exhibited at the *Harmon Foundation* in New York, and has executed a commis-

sion for St. Johns University, Newfoundland, Canada.

In the field of sculpture a number of African artists are well established and count amongst the best in South Africa. Over and above these, there are a number of very talented and promising sculptors. One cannot but think here of the very prominent part played by the capable and devoted teachers of the *Polly Street Art Centre*, and the *Ndaleni Art School* in the development of African sculptural talent. The history of African sculpture in South Africa can never be recalled without giving an important place to these two institutions.

7

Much can be said about why contemporary African art is important, but all reasons cannot be dealt with here. Nevertheless, some of these reasons must be stated. Contemporary African art is a record, and a significant one at that, of what the African is achieving under modern conditions, and it is a means by which the African expresses his relationship with the world. It is of vital importance because the African artist gives shape to ideas, forces and values which otherwise, would be formless.

It is by means of their art that we can be aware of how the Africans in South Africa live and fulfil themselves. We can see, in African society and the activities of their artists, the universal values reflected therein. There are perhaps two major general human trends underlying the complicated reaction of African society to the presence of European society — the need for *self-identification* and the desire for *self-expression*. The oft-times perplexing nature of the Africans' reactions is due to the fact that self-identification may be achieved through the revival of old customs and values, or through the adoption of totally or partly new behaviour patterns, and thus values. Both processes of reaction are evident in contemporary African art. Likewise, self-expression may result in contra-acculturation processes and movements, or in contributions to the present situation, and again both these reactions are present in contemporary African art. Art is *per se* a medium of better understanding of these springs of action, which can enable us to see the African with a sympathetic and understanding eye, thereby contributing not only to a state of empathy but more harmonious human relationships in South Africa. Thus we

can serve by passing on to others the understanding we have gained from contemporary African art, and we can teach that all people are equally human and equally able to achieve what is beautiful, significant and meaningful. In this way contemporary African art can become a vital and powerful vehicle of communication – one that knows no barriers.

The contemporary African artist has ably proved that the African, too, can be an artist of great integrity and achievement. In this way he has contributed to the breaking down of the prejudiced, stereotyped, incorrect vision of the African which is so often held without any questioning of its authenticity or legitimacy.

No doubt can exist about the fact that contemporary African art is off to a good start, and that much can be expected of it in the future; already in South Africa it has a well established tradition comparable to the best anywhere in the world. It is a legacy to the African past, and indicative of what can be expected of the future on this continent.

One cannot but agree with Willet[23] when he refers to modern African art in general to the effect that it seems likely that posterity will judge the second half of the twentieth century to have been a period of artistic renaissance for Africa as a whole.

History has long since ceased to be recorded only in verse and prose. Consequently the art of a people is a recording of their history, a reflection, in artistic images, of their existence, experience and hopes. Contemporary African art, however, does not only reflect back to the contemporary world but also moves forward with great promise.

References

1 We can here, however, mention: Beier, U.: *Contemporary Art in Africa*, London, 1968. Chapter 7 in Willet, F.: *African Art*, London, 1971. Various entries in Berman, E.: *Art and Artists in South Africa*, Cape Town, 1970, deal more specifically with South Africa. See also Battiss, W.: "A New African Art in South Africa", *Optima*, Vol. 17. 1967. There are also a large number of articles, reviews, etc. on individual African artists in South Africa contained in periodicals such as: *Artlook* (Johannesburg), *The Classic* (Johannesburg), *African Arts* (Los Angeles), *Lantern* (Pretoria), etc.

2 *Optima*, Vol. 16, 1966, No. 1.

3 *Optima, loc. cit.*

4 Tempels, P.: *Bantu Philosophy*, Paris, 1954.

5 Raum, O. F.: "Artist, Art Patron and Art Critic in Changing Africa", *Fort Hare Papers*, Vol. 3, No. 5, 1966.

6 Berman, E.: *Op. cit.*, p. 17.

7 Battiss, W.: *Op cit.*

8 cf. Berman, E.: *Op. cit.*, p. 268. Battiss, W.: "Gerard Sekoto" in *Ons Kuns*, Pretoria, pp. 103–107.

9 cf. Savory, P.: *Gerard Bhengu – Zulu Artist*, Cape Town, 1965. Schlösser, K.: "Gerard Bhengu: Einige phasen seines Schaffens" *in* De Jager, E. J.: *Man: Anthropological Essays presented to O. F. Raum*, Cape Town, 1971.

10 cf. Berman, E.: *Op. cit.*, p. 244.

11 cf. Berman, E.: *Op. cit.*, p. 244. Also: *Bantu*, Vol. 19, 1972, pp. 30–31.

12 *Artlook 15*, 1968, p. 6.

13 cf. Berman, E.: *Op. cit*, p. 211.

14 cf. Berman, E.: *Op cit.*, p. 192. *Artlook 35*, 1969, p. 30.

15 *Artlook 30*, 1969, p. 20. *Artlook 43*, 1970, pp. 9–11. *Artlook 50* 1971, pp. 26–29.

16 Berman, E.: *Op. cit.*, p. 186.

17 Watter, L.: "Louis Maqhubela", *The Classic*, Vol. 3, 1969, p. 26.

18 Berman, E.: *Op. cit.*, p. 186.

19 Berman, E.: *Op cit.*, p. 84.

20 Berman, E.: *Op. cit.*, p. 17.

21 Watter, L.: "Sydney Kumalo – Sculptor", *Lantern*, Vol. 18, 1968, pp. 34–42.

22 The author is indebted to Dr Wolfgang Bodenstein for the information on Michael Zondi.

23 Willet, F.: *African Art*, London, 1971.

1. NGCOBO, E. **Festive Spirit.** 1963. Oil. 122 x 61 cm.

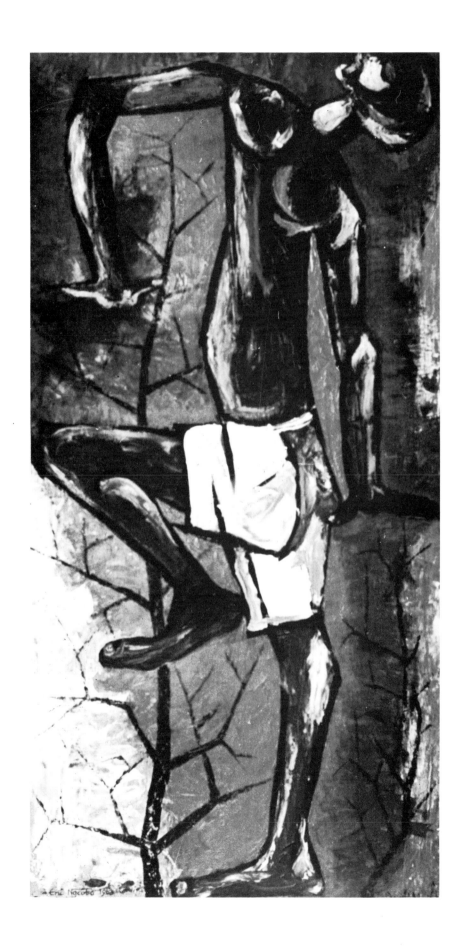

2. PEMBA, G. M. **Old Man.** Water-colour. 35 x 27 cm.

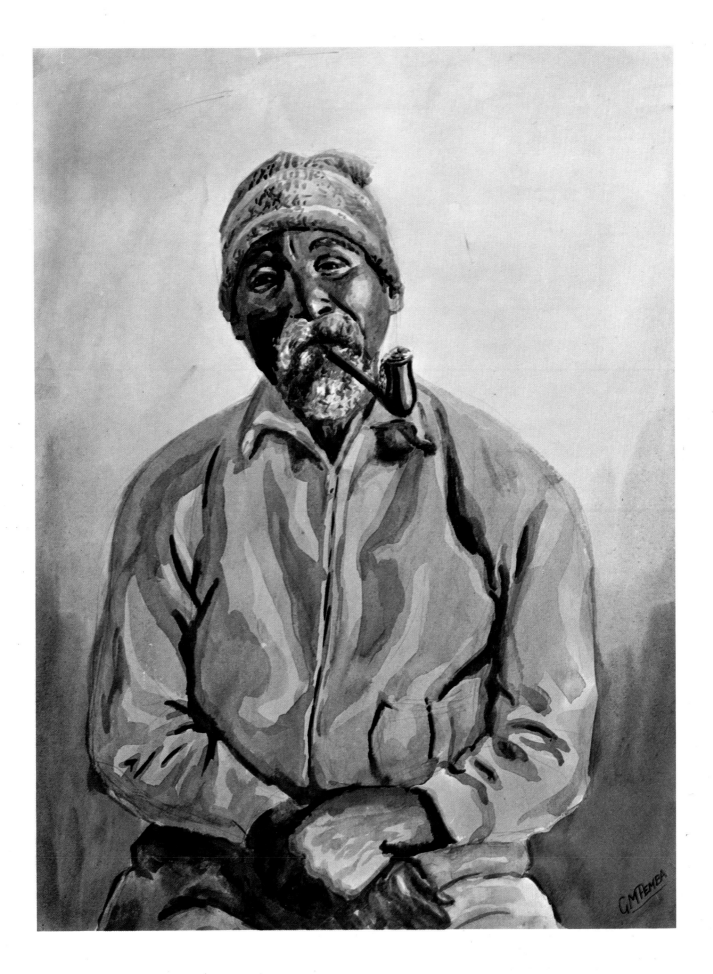

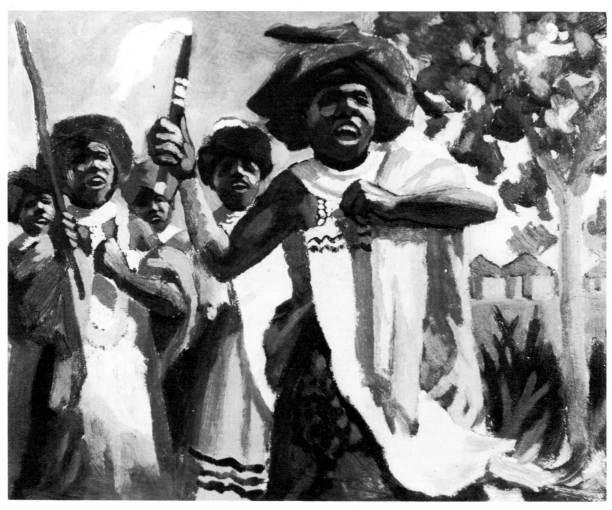

3. PEMBA, G. M. **Dancing Women.** Oil. 48 x 38 cm.

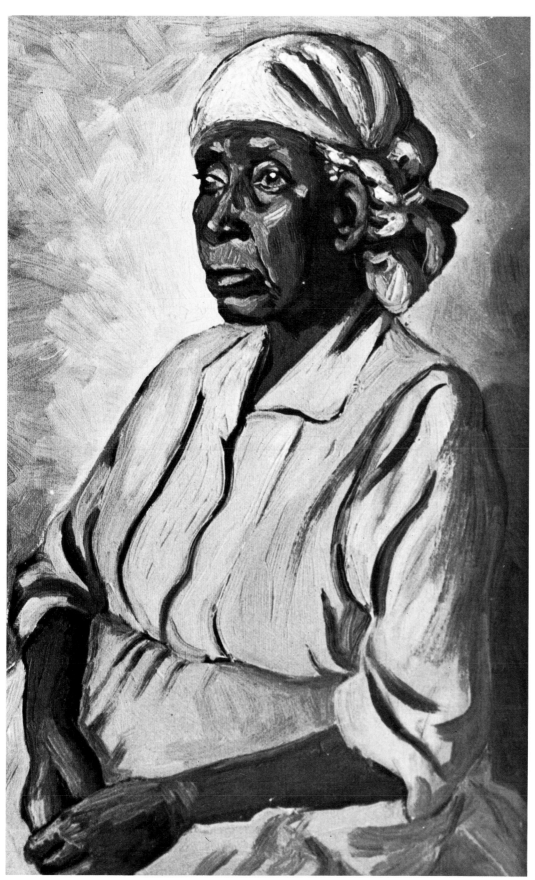

4. PEMBA, G. M. **Xhewu.** Oil. 46 x 37 cm.

5. PEMBA, G. M. **Woman.** 1940. Water-colour. 37 x 26 cm.

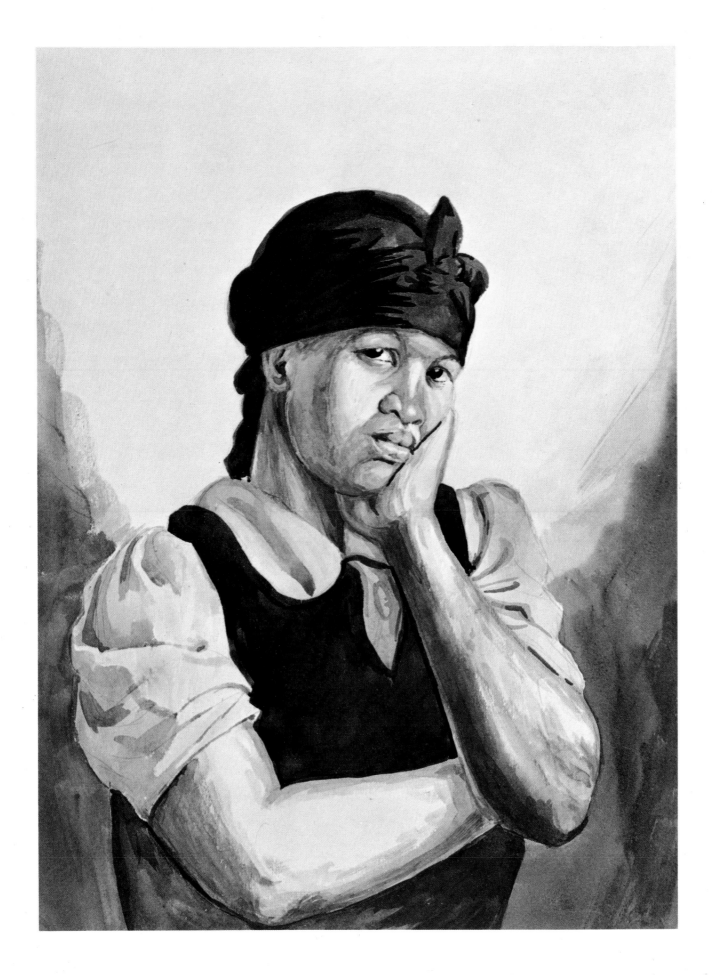

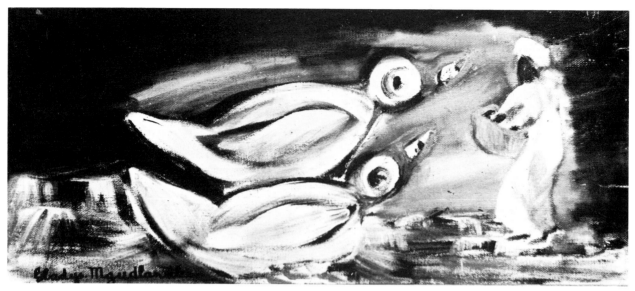

6. MGUDLANDLU, G. **The Birds.** Oil. 81 x 34 cm.

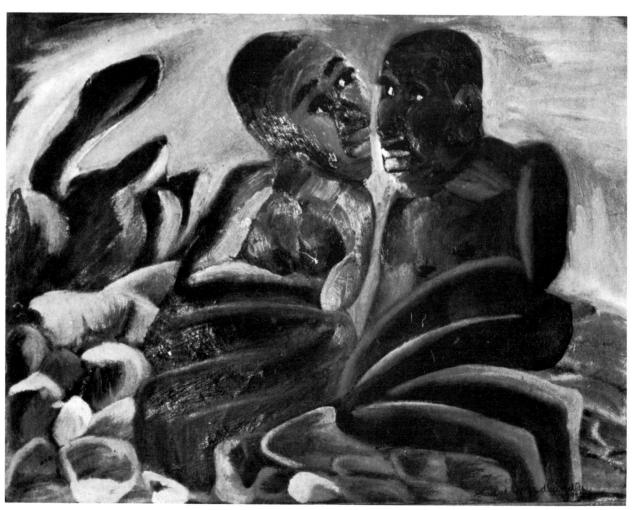

7. MGUDLANDLU, G. **Newly-weds.** 1964. Oil.

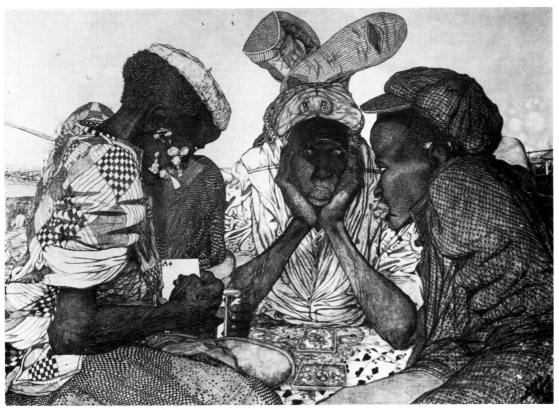

8. MOTJUOADI, A. **Playing Cards.** 1966. Pencil. 73 x 106 cm.

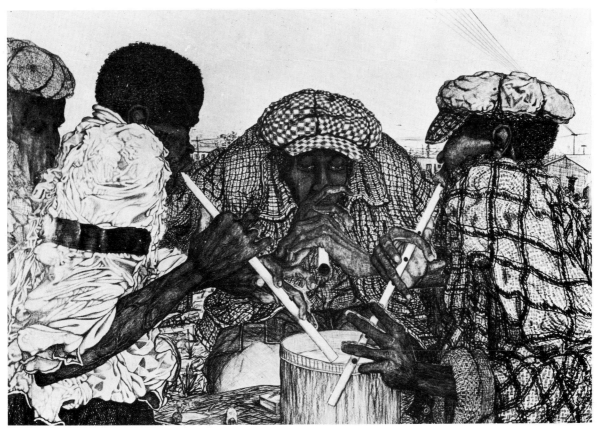

9. MOTJUOADI, A. **Township Musicians.** 1966. Pencil. 75 x 108 cm.

10. SEKOTO, G. **Four Men and a Guitar.** Oil. 51 x 58 cm.

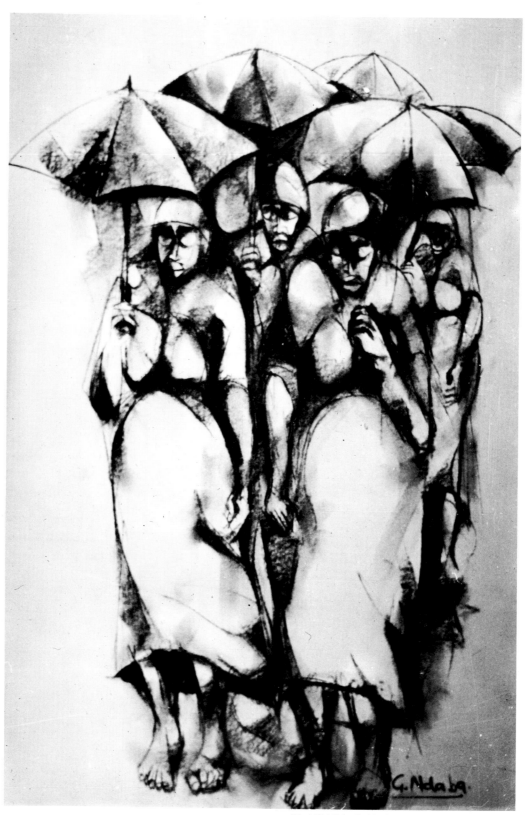

11. NDABA, G. **Umbrellas.** Pencil. 48 x 35 cm.

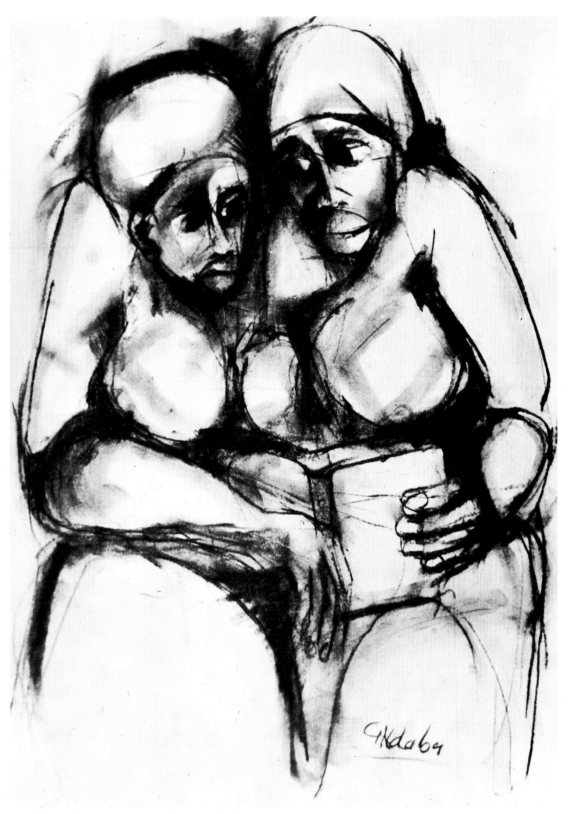

12. NDABA, G. **Women Reading.** Pencil. 48 x 35,5 cm.

13. BHENGU, G. **Homeward Bound.** 1941. Water-colour. 18 x 38 cm.

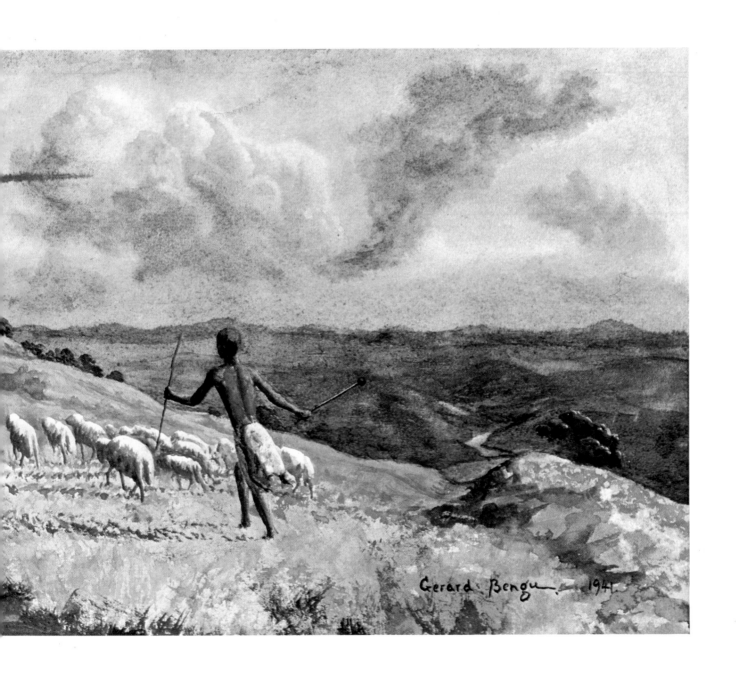

14. BHENGU, G. **Ntombentle.** Sepia. 30 x 38 cm.

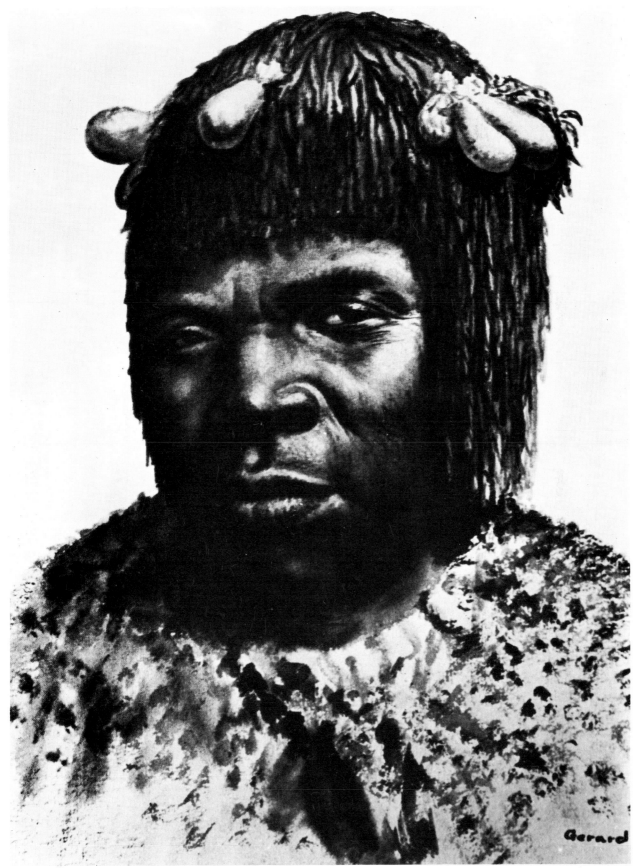

15. BHENGU, G. **Umyeku.** Sepia. 30 x 38 cm.

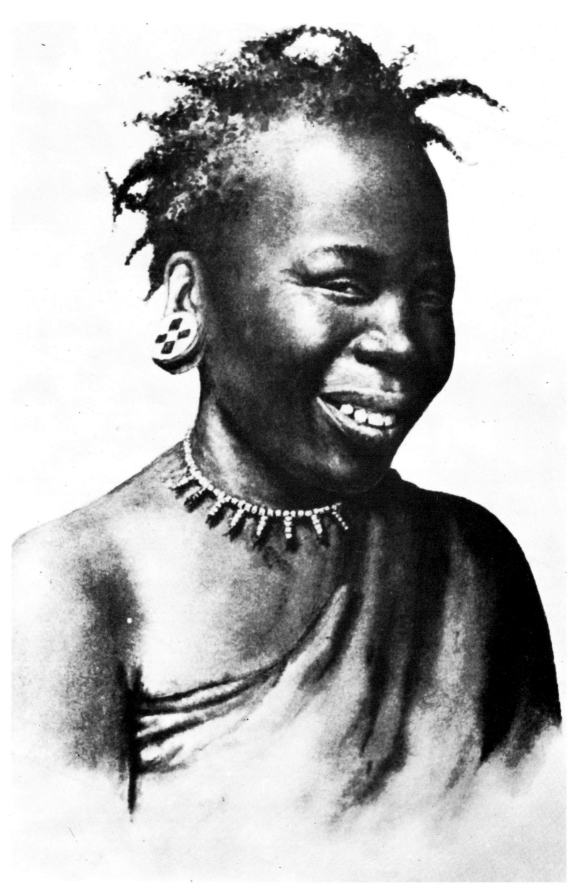

16. BHENGU, G. **Tsi-viva.** Sepia. 30 x 38 cm.

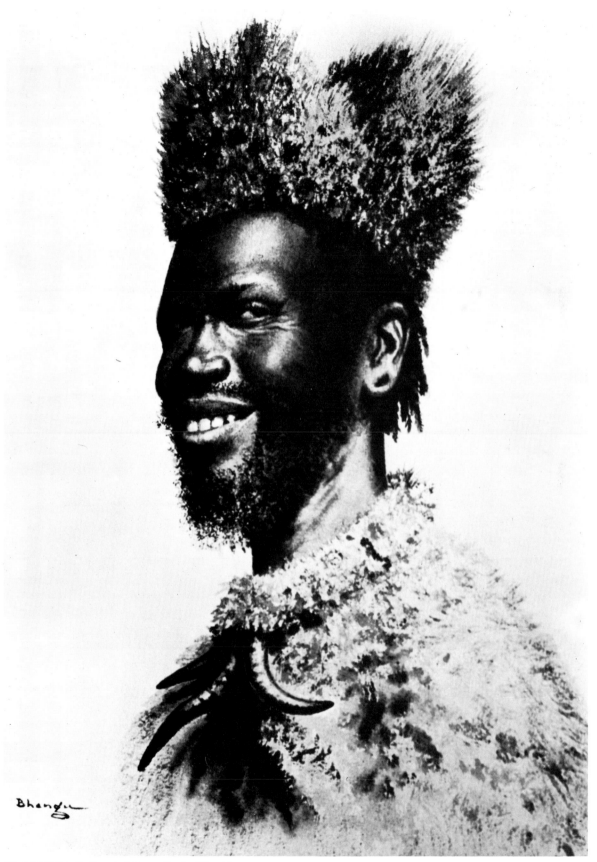

17. BHENGU, G. **Bearded Beau.** Sepia. 30 x 38 cm.

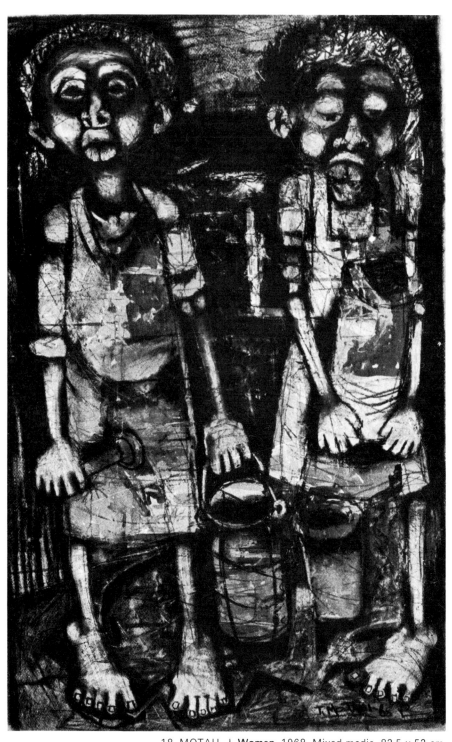

18. MOTAU, J. **Women.** 1968. Mixed media. 82,5 x 52 cm.

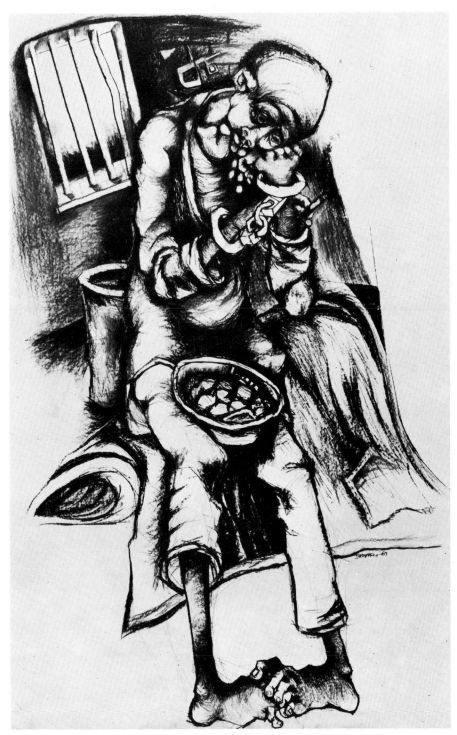

19. MOTAU, J. **Man in Jail.** 1967. Charcoal. 152,5 x 101,6 cm.

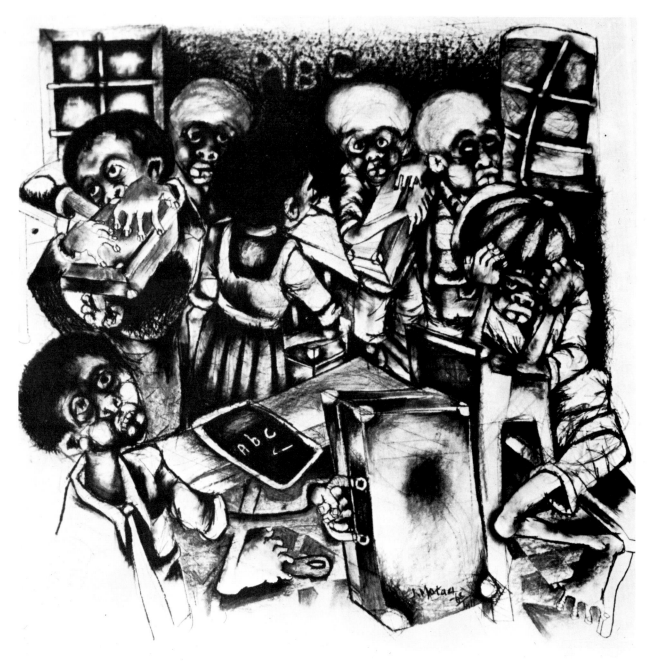

20. MOTAU, J. **Classroom.** 1968. Charcoal. 91 x 91 cm.

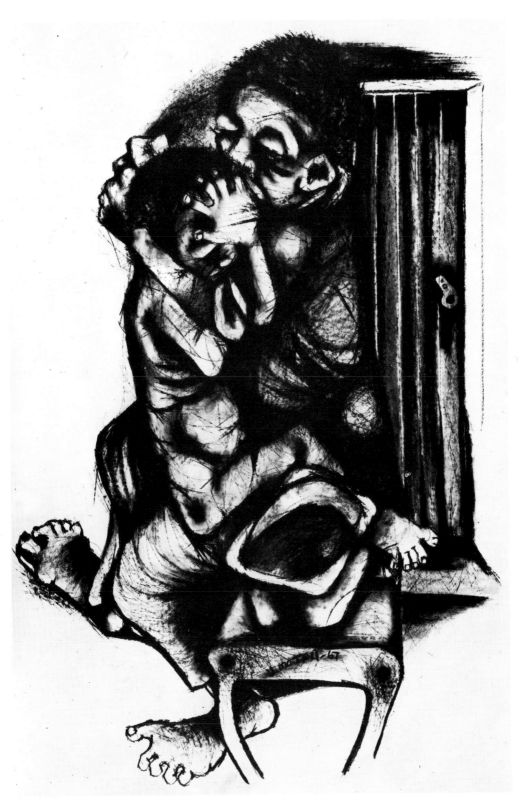

21. MOTAU, J. **Mother and Child.** 1967. Charcoal.

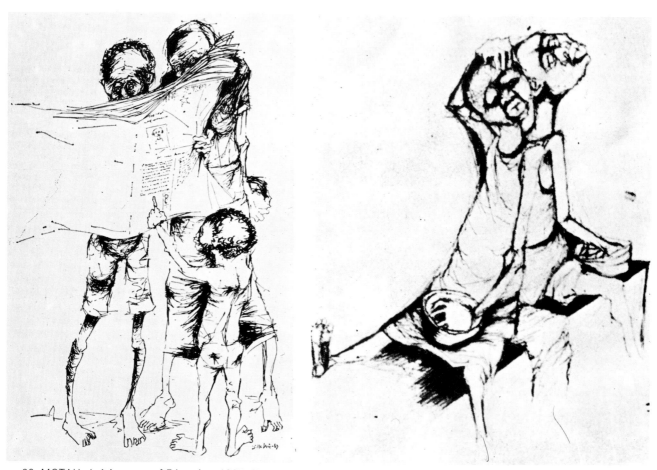

22. MOTAU, J. **Advantage of Education.** 1967. Charcoal.

23. MOTAU, J. No title. 1967. Charcoal.

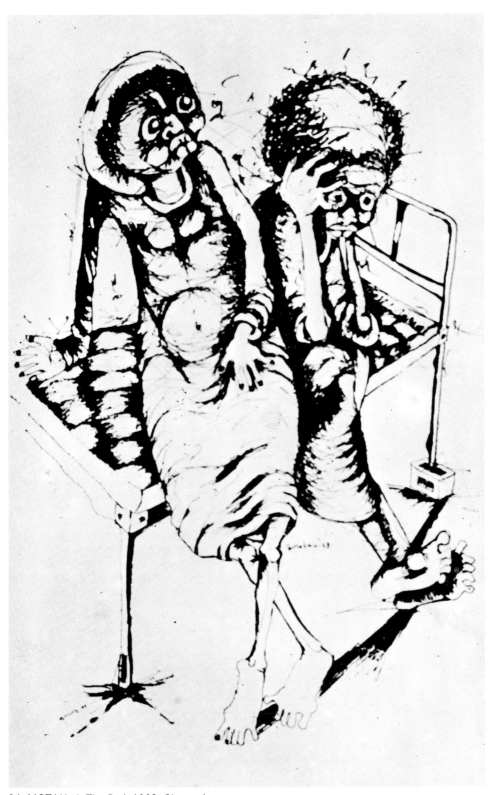

24. MOTAU, J. **The Bed.** 1968. Charcoal.

(Left) (Right)

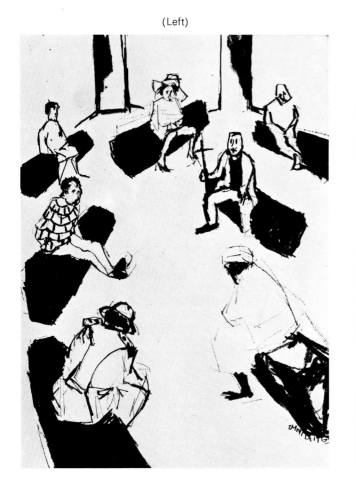 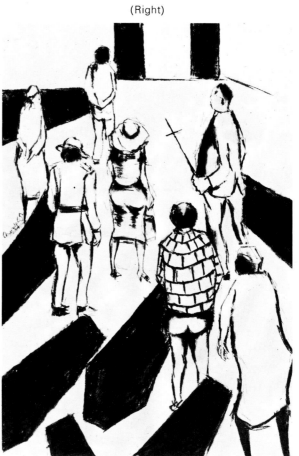

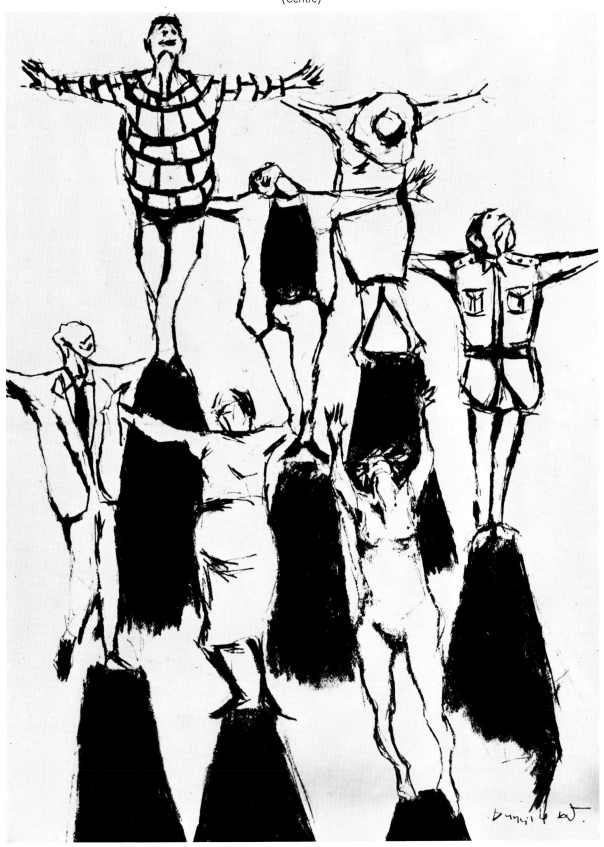

25. DUMILE, M. **The Resurrection.** 1965. Triptych. Charcoal. 58,4 x 38,1 cm.

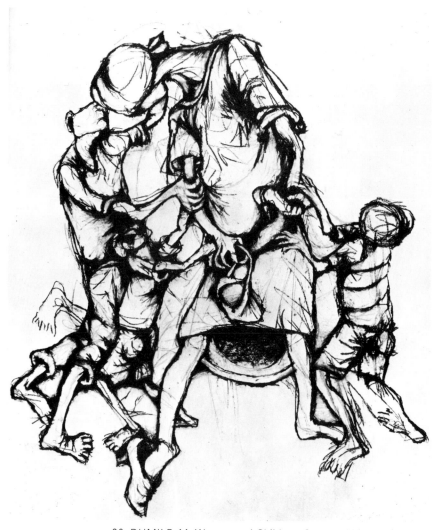

26. DUMILE, M. **Woman and Children.** Crayon. 118,5 x 101,8 cm.

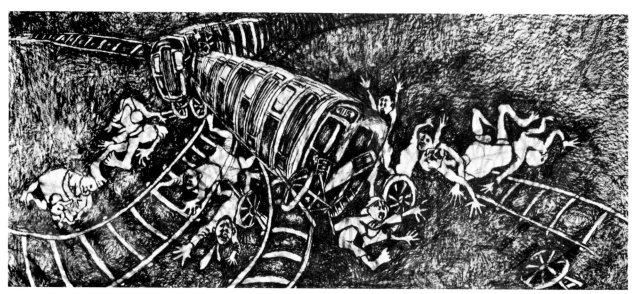

27. DUMILE, M. **Railway Accident.** 1966. Crayon. 102,3 x 237,2 cm.

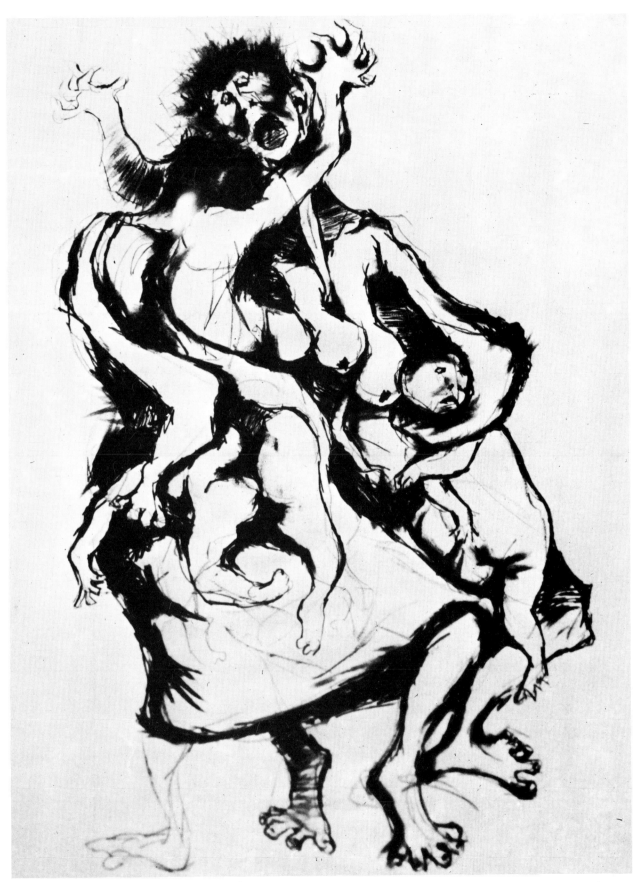

28. DUMILE, M. **Harpy.** Charcoal.

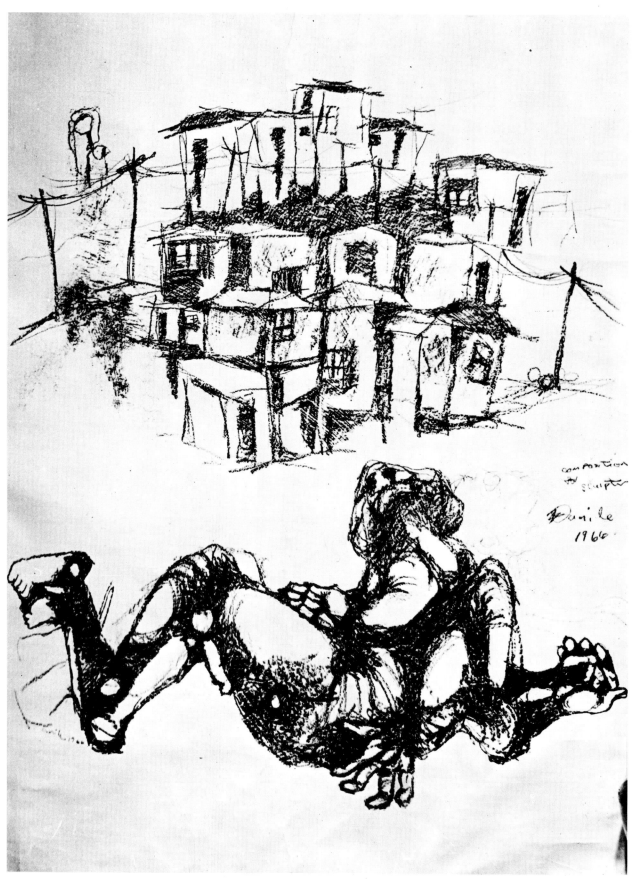

29. DUMILE, M. **Kwa Mashu.** 1966. Crayon.

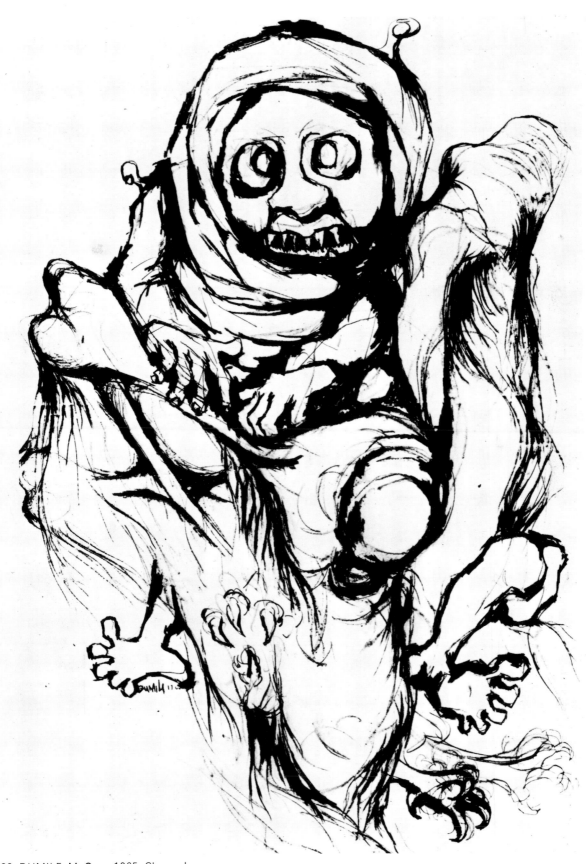

30. DUMILE, M. **Ogre.** 1965. Charcoal.

31. MBELE, D. **Boy with a Suitcase.** Chalk. 32 x 50 cm.

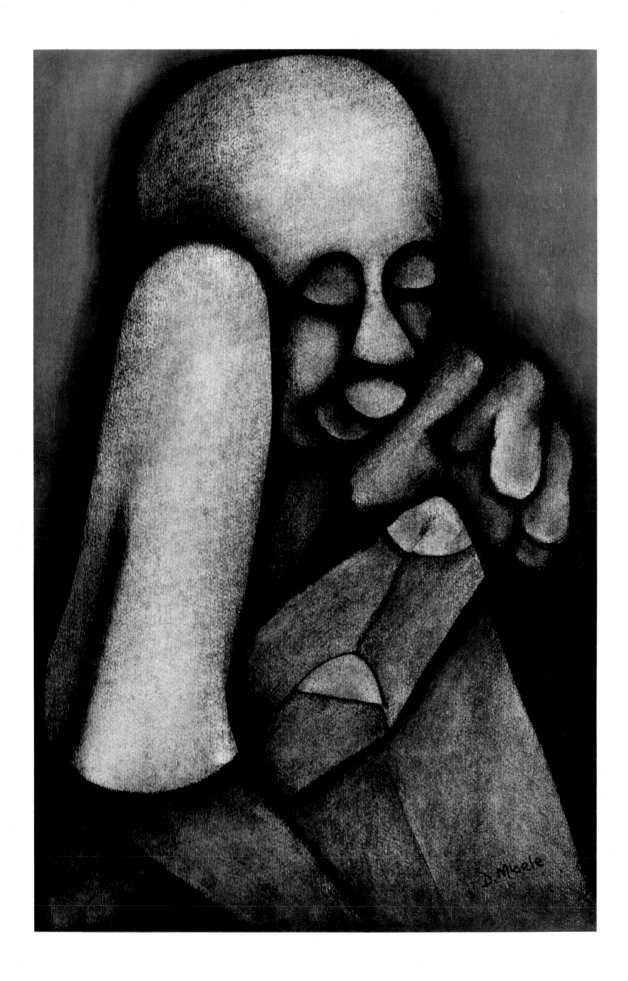

(Left)

(Right)

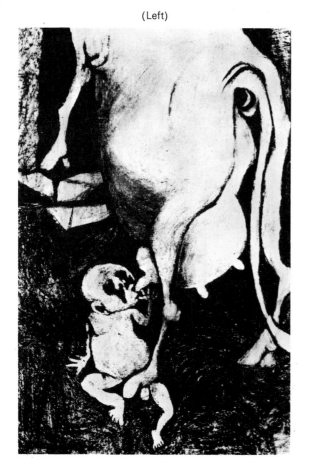

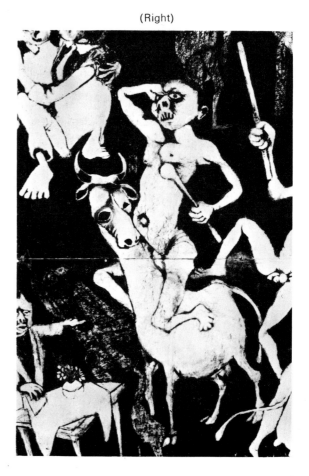

(Centre)

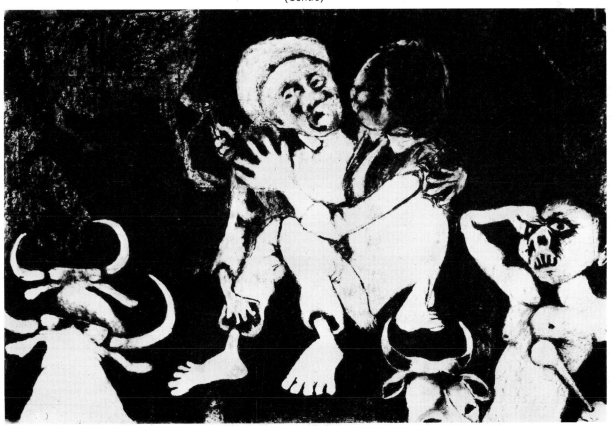

32. DUMILE, M. **African Guernica.** (Three details). Charcoal. 3,3 x 2,7 m.

33. SEKOTO, G. **Street Scene.** Oil. 30,5 x 40,5 cm.

34. DUMILE, M. **Animals.** 1966. Crayon. 112 x 103,5 cm.

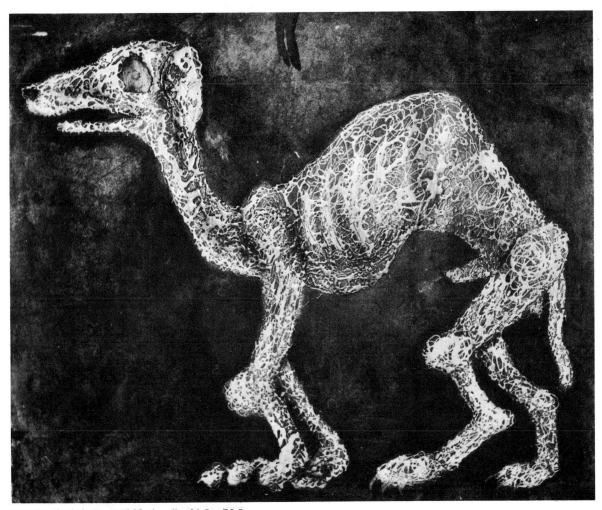

35. SITHOLE, L. **Dog.** 1962. Acrylic. 91,5 x 73,5 cm.

36. MBELE, D. **Friends.** Chalk. 71 x 55 cm.

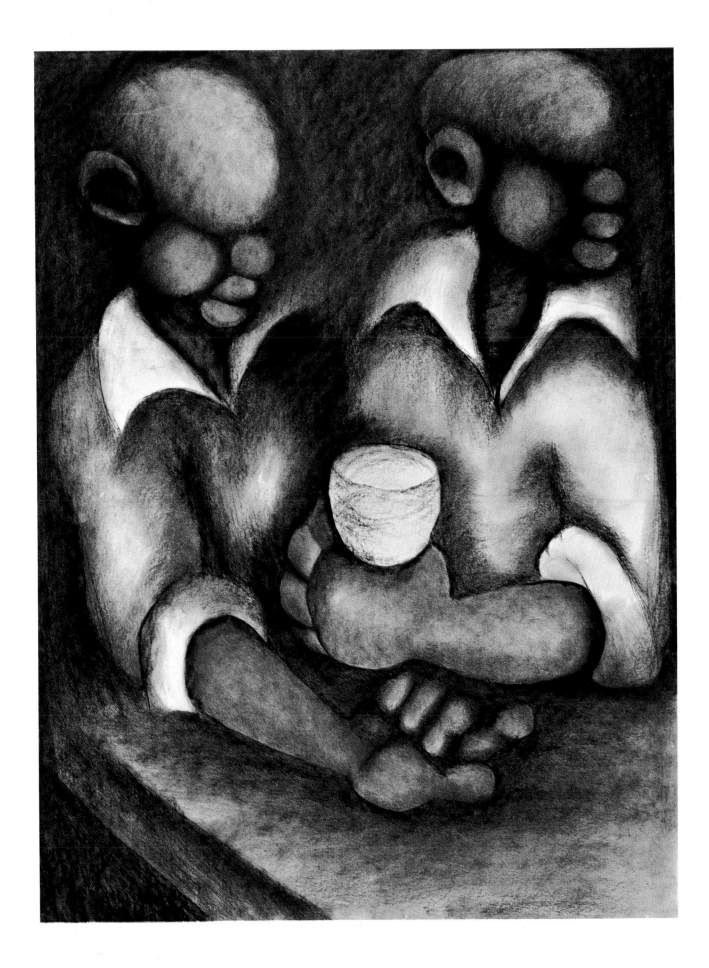

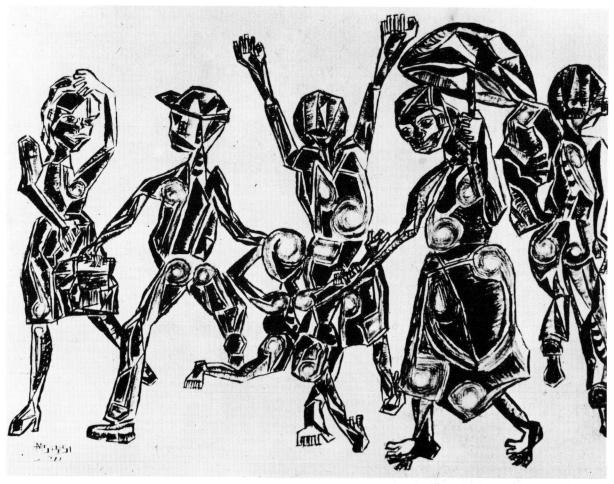

37. SIBISI, P. **People I meet.** 1972. Ink. 43 x 61 cm.

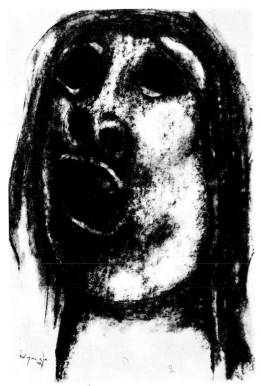

38. MACALA, B. **Head.** 1969. Crayon. 68,5 x 48,4 cm.

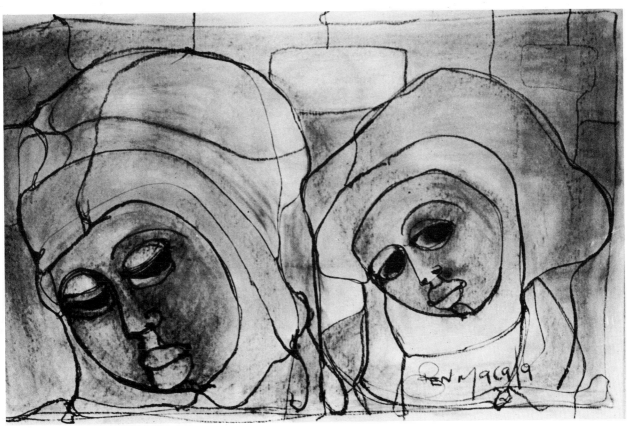

39. MACALA, B. **Two Heads.** 1972. Crayon.

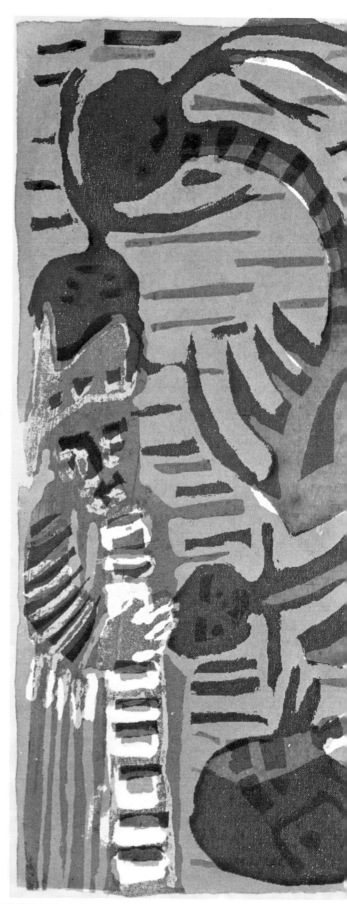

40. MBATHA, A. **John and the Beast.** Serigraph. 40,5 x 35 cm.

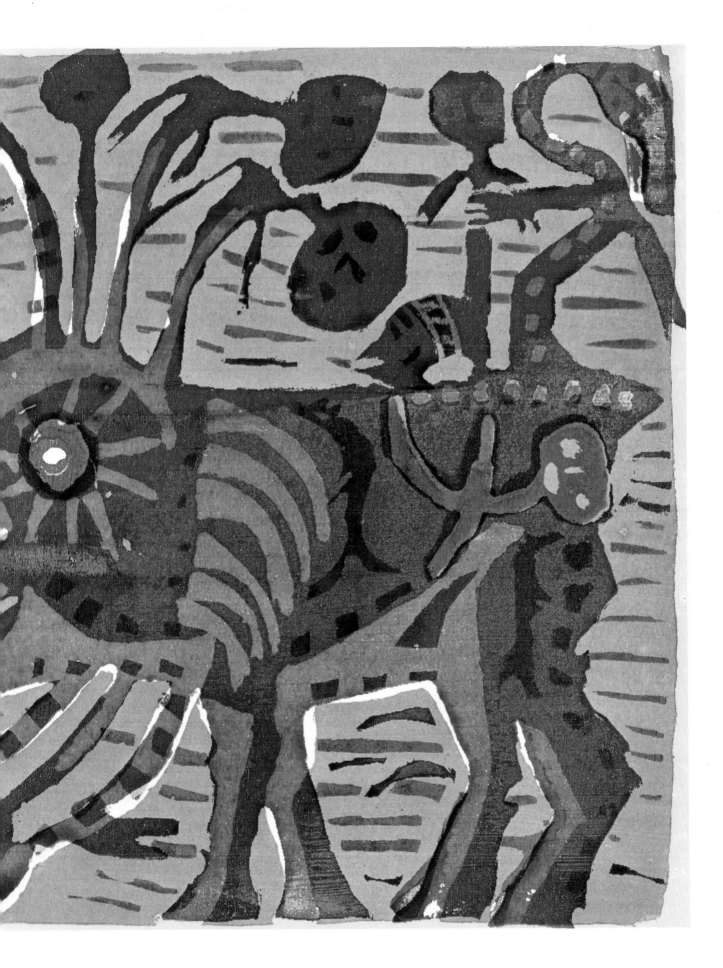

41. MBELE, D. **Nude.** Chalk. 71 x 51 cm.

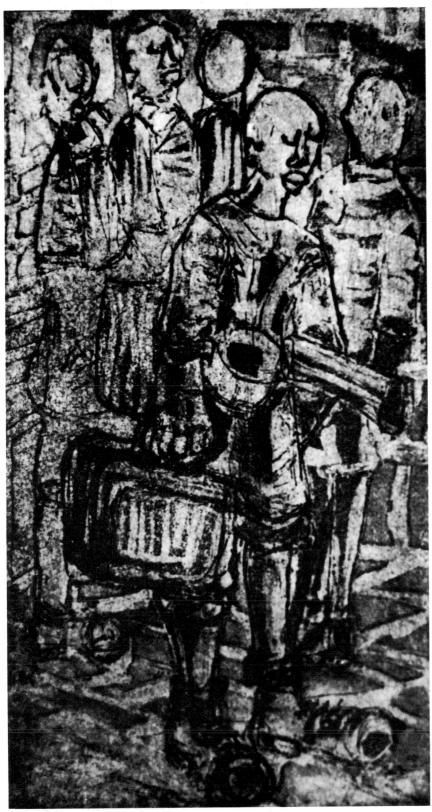

42. MBATHA, E. **Newcomer.** 1972. Etching. 35,5 x 20 cm.

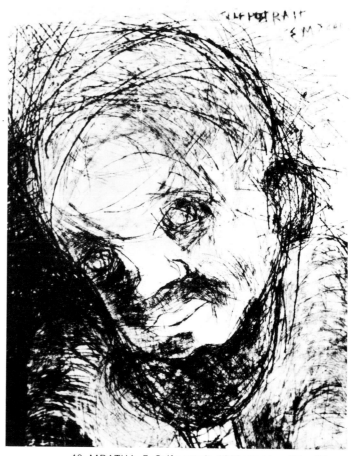

43. MBATHA, E. **Self portrait.** 1972. Etching. 35 x 30 cm.

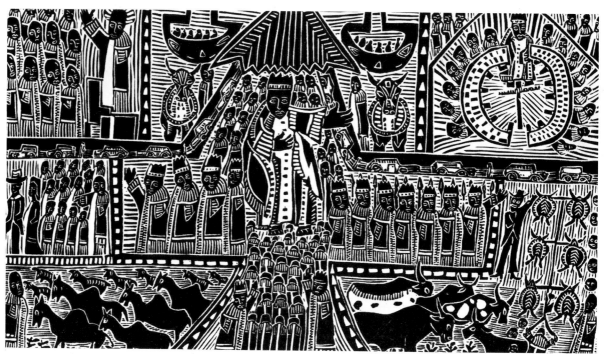

44. MBATHA, A. **Invitation.** Linocut. 48 x 28 cm.

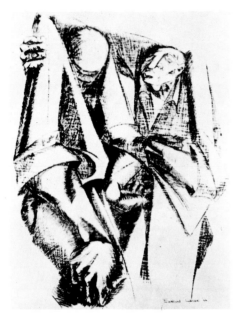

45. LEGAE, E. **The Mourners.** 1966.

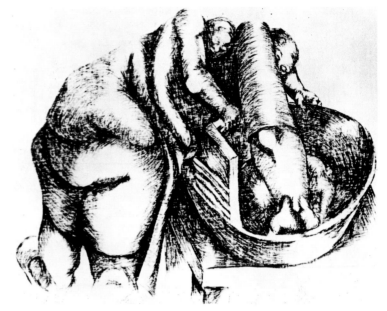

46. LEGAE, E. **Washer Women.** 1966.

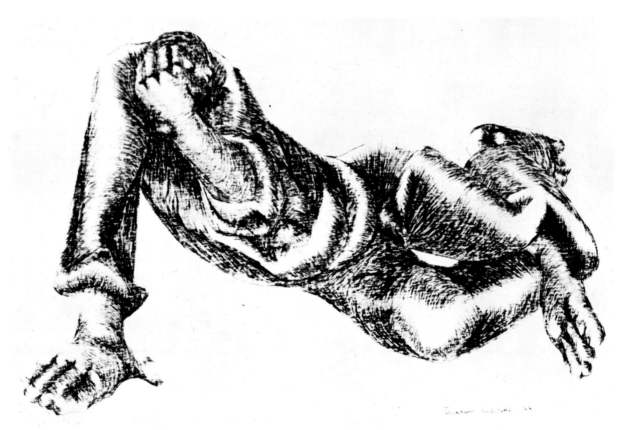

47. LEGAE, E. **Regret.** 1966.

48. SAOLI, W. **Sunrise to Sunset**. 1972. Water-colour and Ink. 47 x 36 cm.

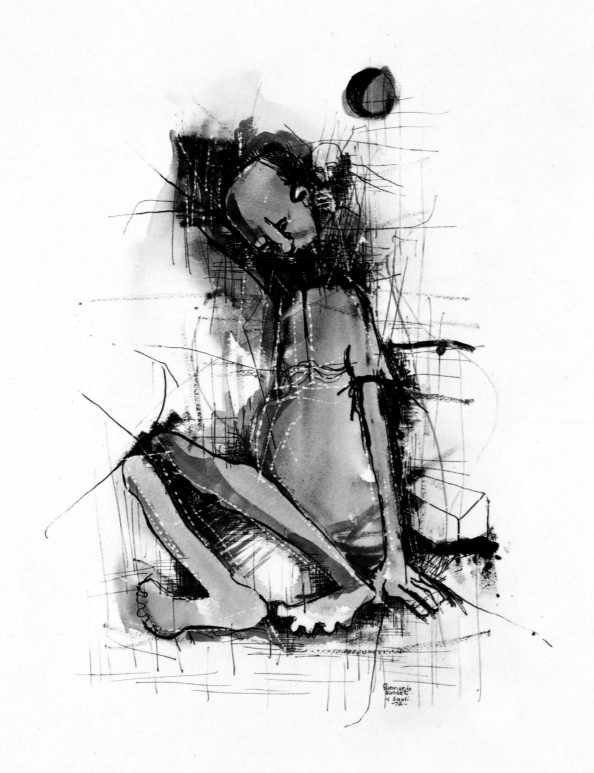

49. SHILAKOE, C. **Figure.** 1968. Etching. 38 x 24 cm.

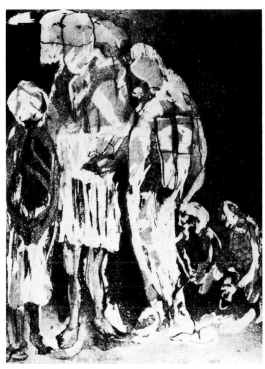

50. SHILAKOE, C. **We are Leaving.** 1969. Etching. 28 x 21,5 cm.

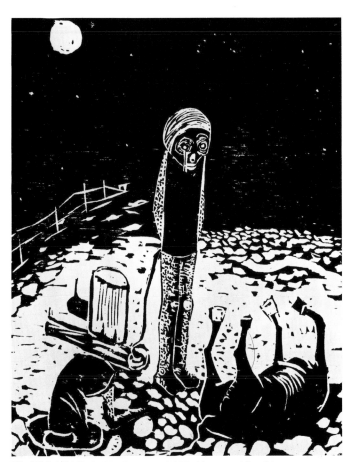

51. SHILAKOE, C. **My Donkey.** 1970. Linocut. 28 x 21 cm.

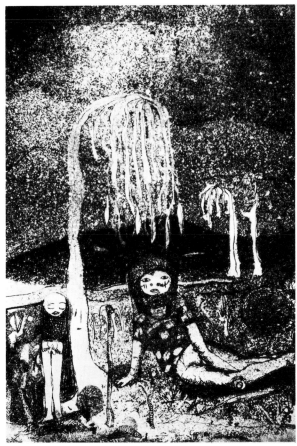

52. SHILAKOE, C. **Loneliness.** 1971. Etching. 30,5 x 21,5 cm.

53. SAOLI, W. **Twilight.** Oil. 37 x 34 cm.

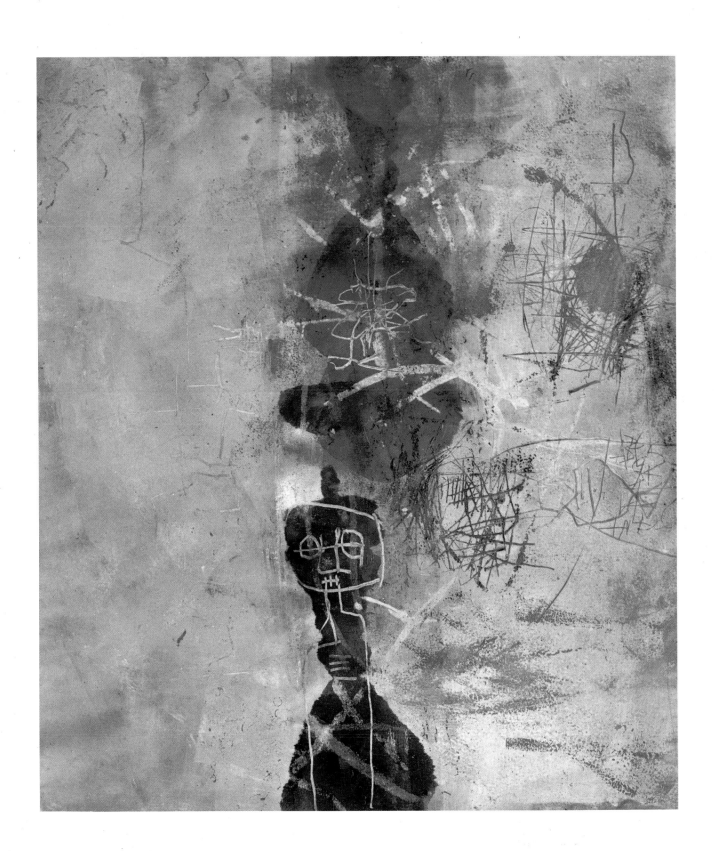

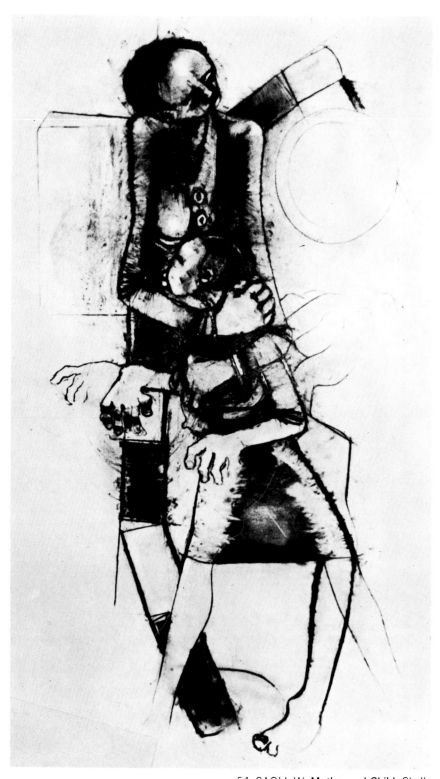

54. SAOLI, W. **Mother and Child.** Chalk.

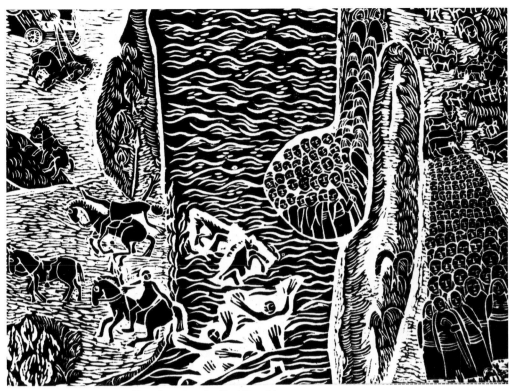

55. NDLOVU, A. **The Israelites Crossing the Red Sea.** Linocut.

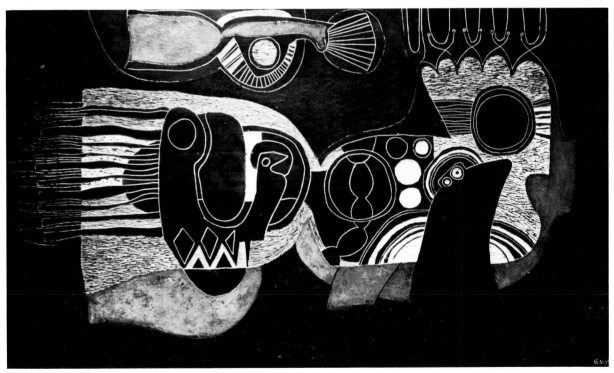

56. SIBIYA, L. **Flight.** Wood panel.

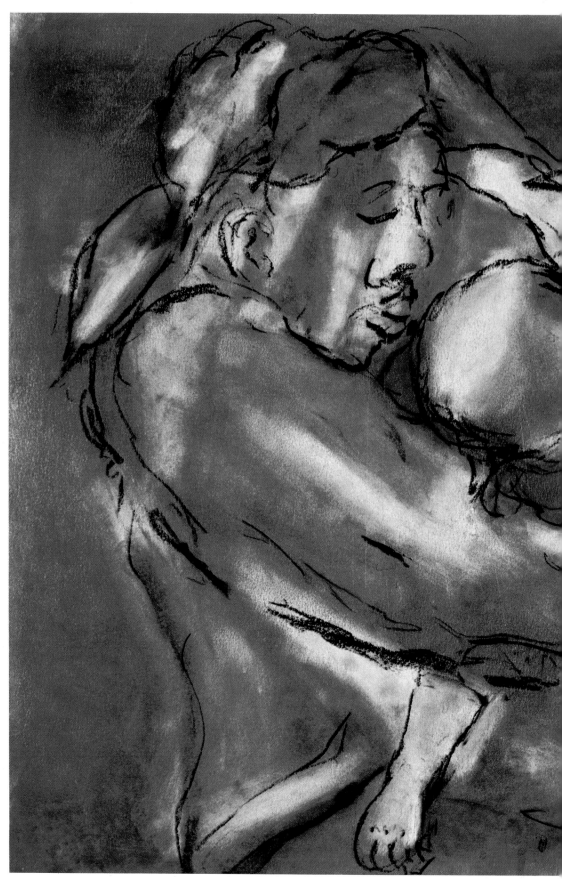

57. NTULI, M. **Mother and Child.** 1967. Chalk. 72 x 48 cm.

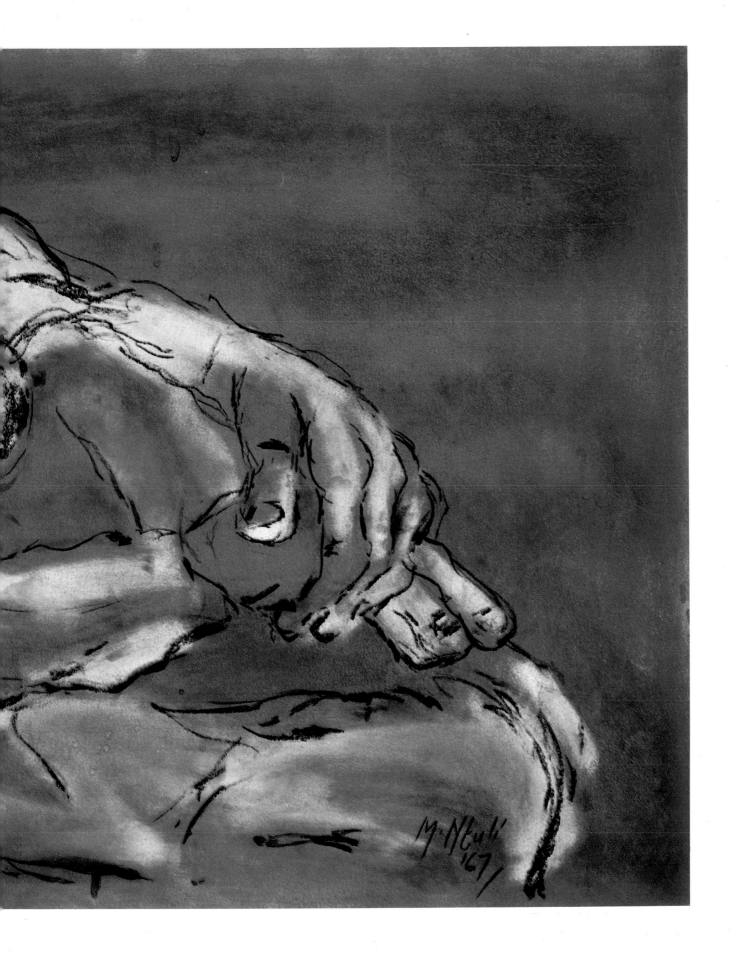

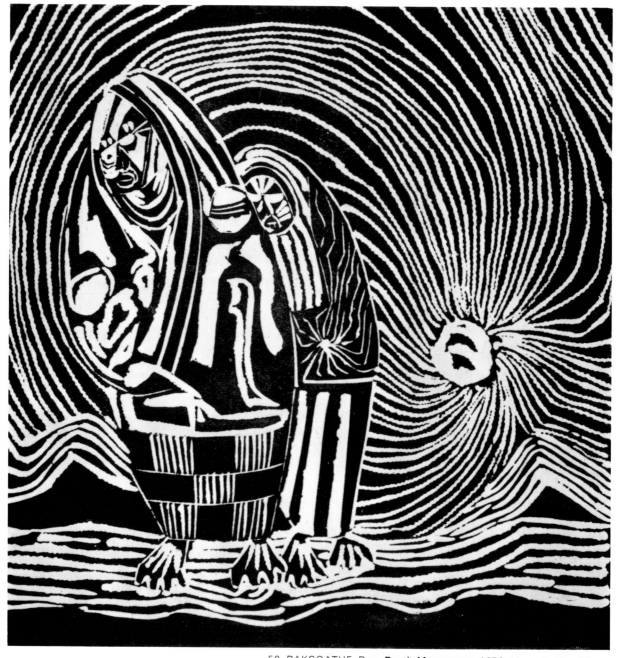

58. RAKGOATHE, Dan. **Death Messengers.** 1970. Linocut. 40 x 34 cm.

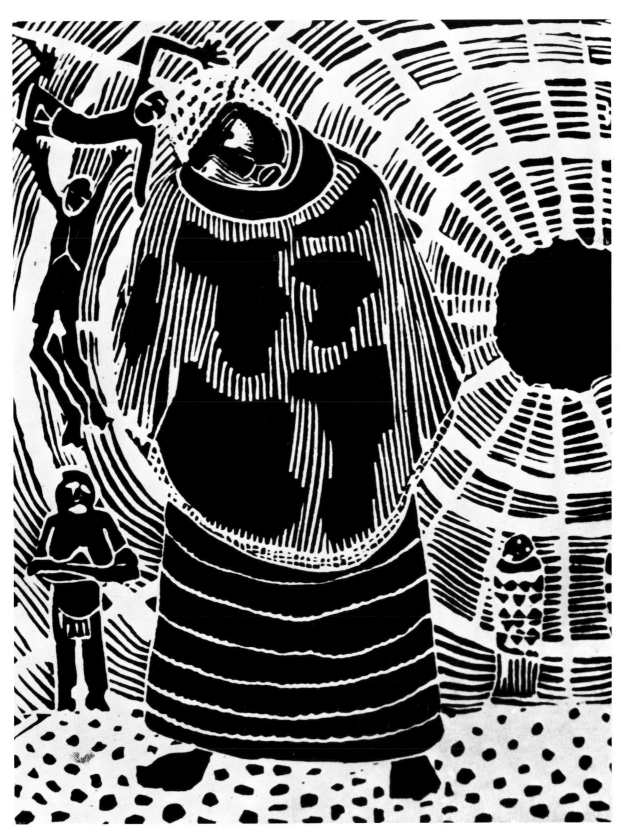

59. RAKGOATHE, Dan. **Trap of Conscience.** 1972. Linocut. 40 x 35 cm.

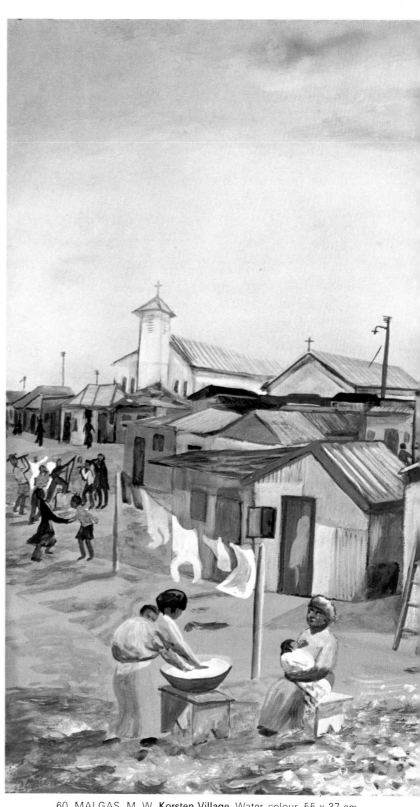

60. MALGAS, M. W. **Korsten Village.** Water-colour. 55 x 37 cm.

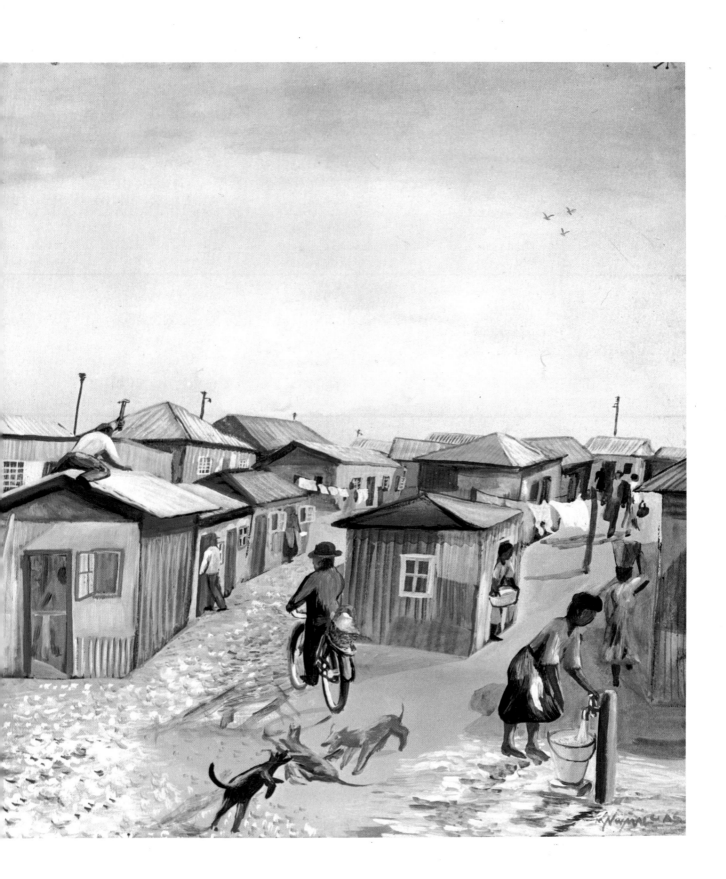

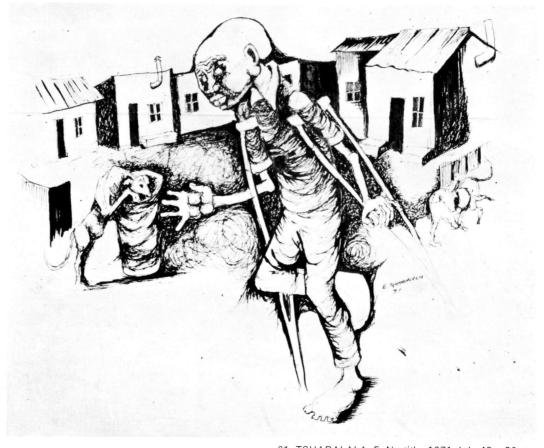

61. TSHABALALA, E. No title. 1971. Ink. 48 x 36 cm.

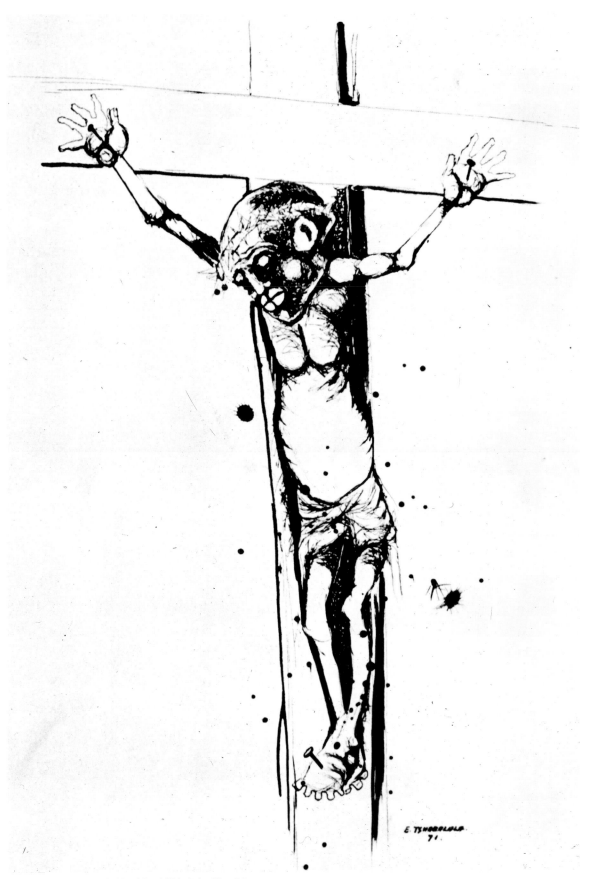

62. TSHABALALA, E. No title. 1971. Ink. 48 x 36 cm.

63. MASEKO, J. **Township.** Water-colour. 48 x 33 cm.

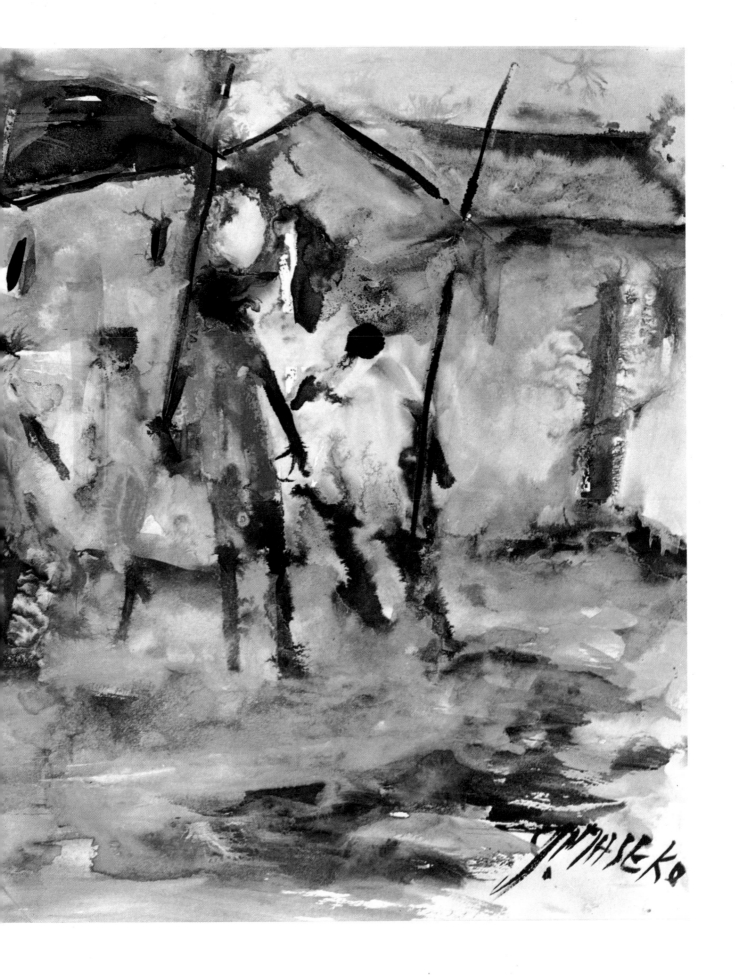

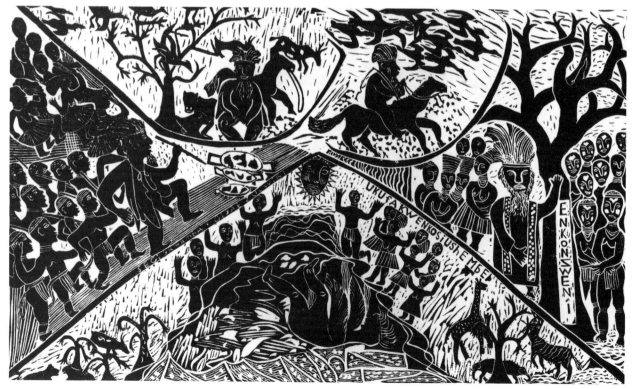

64. NXAMALO, C. **The Shembe Story.** Linocut. 62 x 40,5 cm.

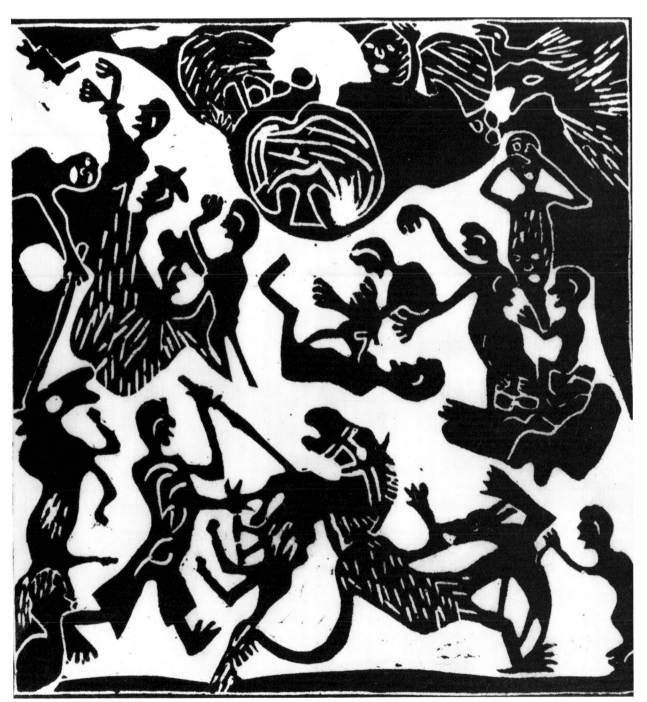

65. KAFENJE, I. **A Battle Long Ago.** Linocut.

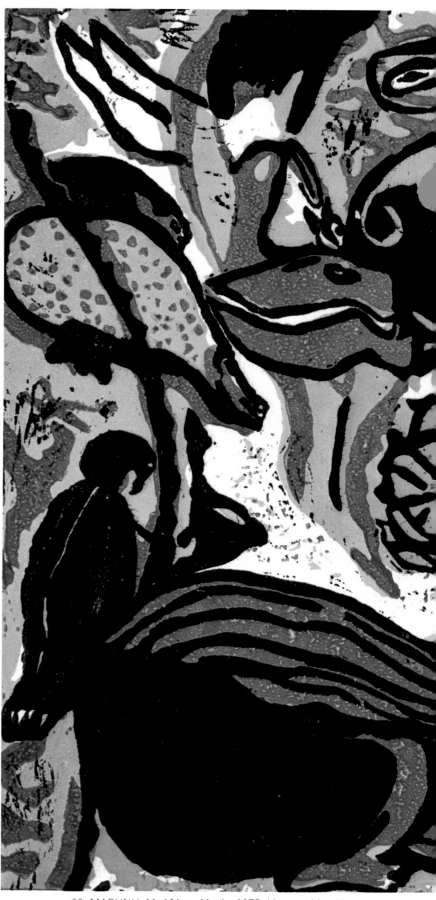

66. MABUNU, M. **African Magic.** 1972. Linocut. 38 x 30,5 cm.

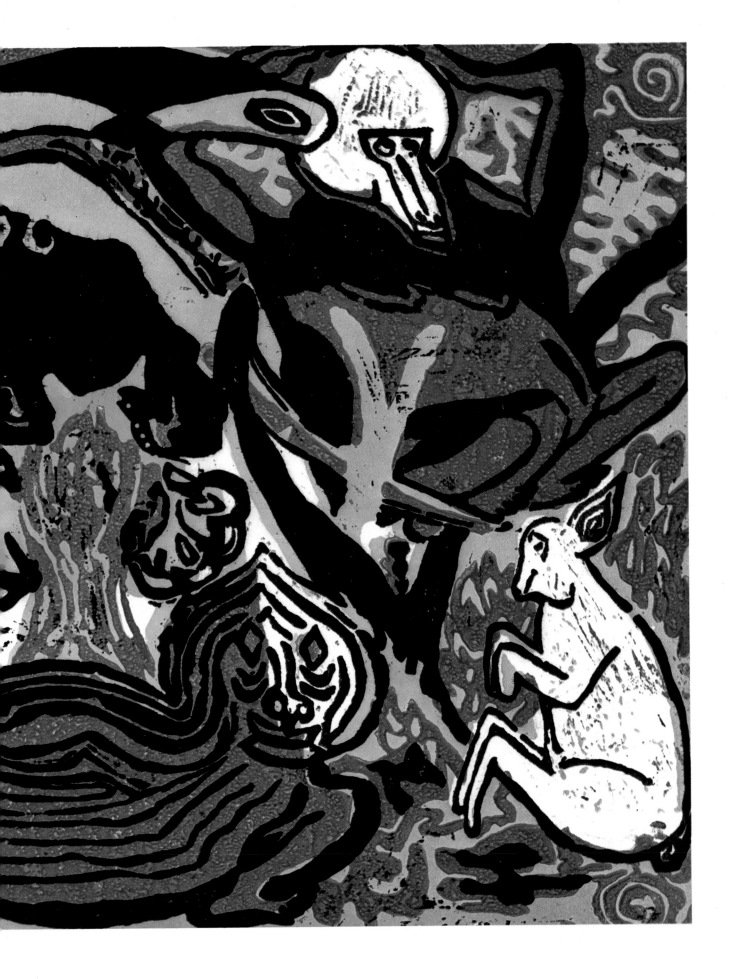

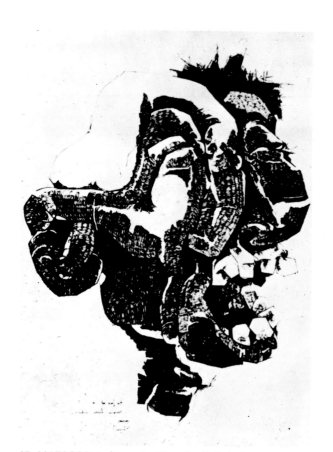

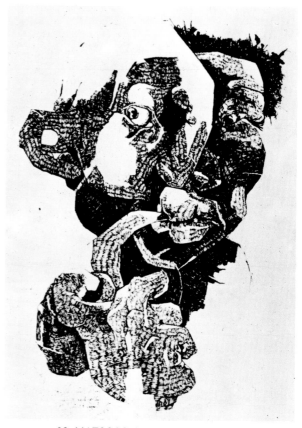

67. MATSOSO, L. **Face of a Charging Zulu Induna.** 1971. Ink.

68. MATSOSO, L. **Man Smoking Pipe.** 1971. Ink.

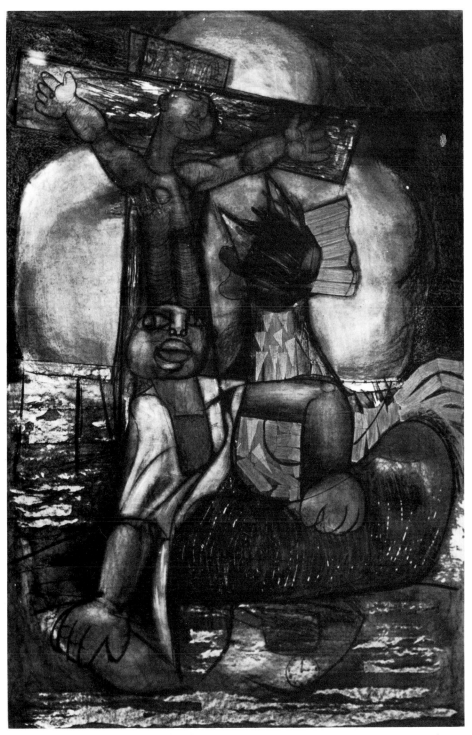

69. MAQHUBELA, L. Peter's Denial. Chalk.

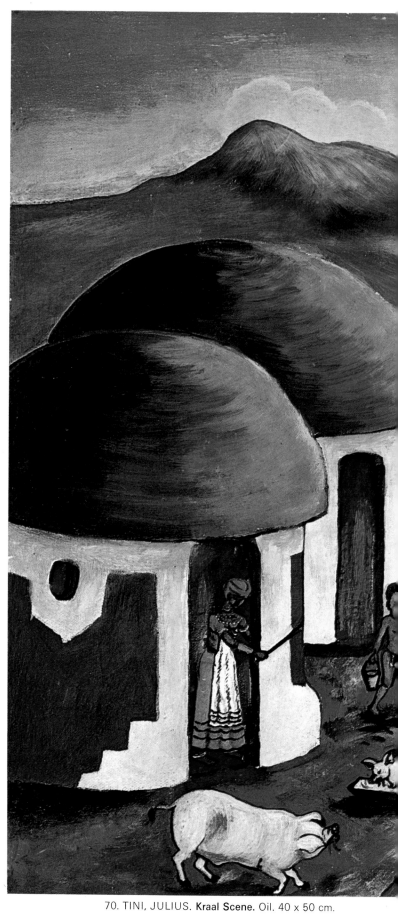

70. TINI, JULIUS. **Kraal Scene.** Oil. 40 x 50 cm.

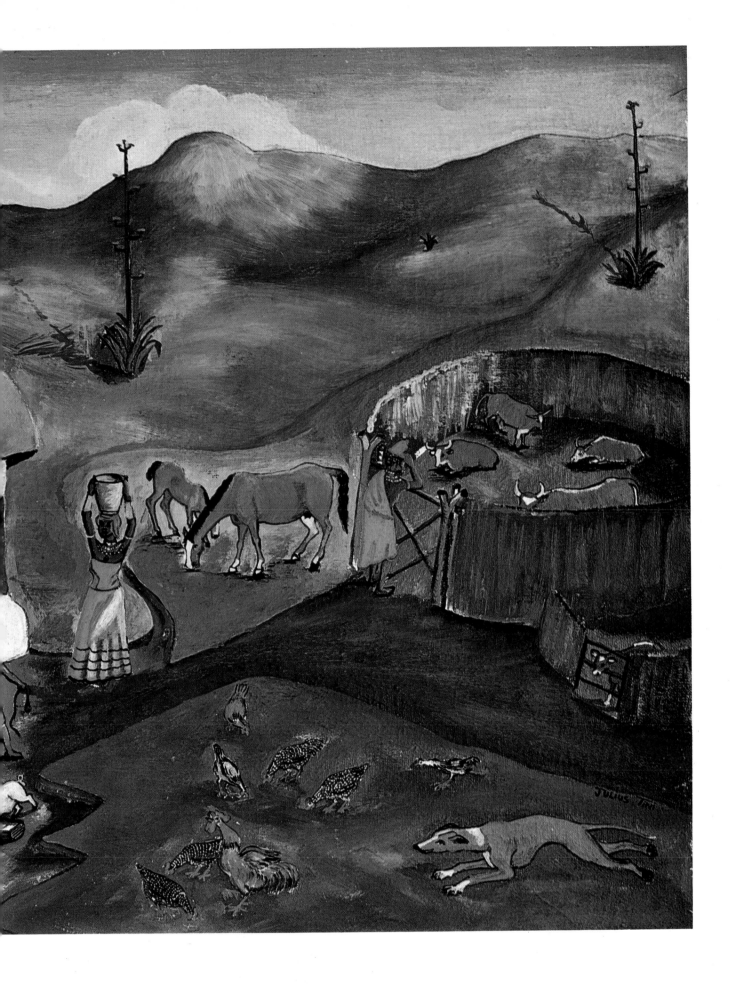

71. NOLUTSHUNGU, H. **Standing Figures.** 1972. Etching. 25,5 x 55,5 cm.

72. NOLUTSHUNGU, H. **Reading the Sermon.** 1972. Etching. 25,5 x 35,5 cm.

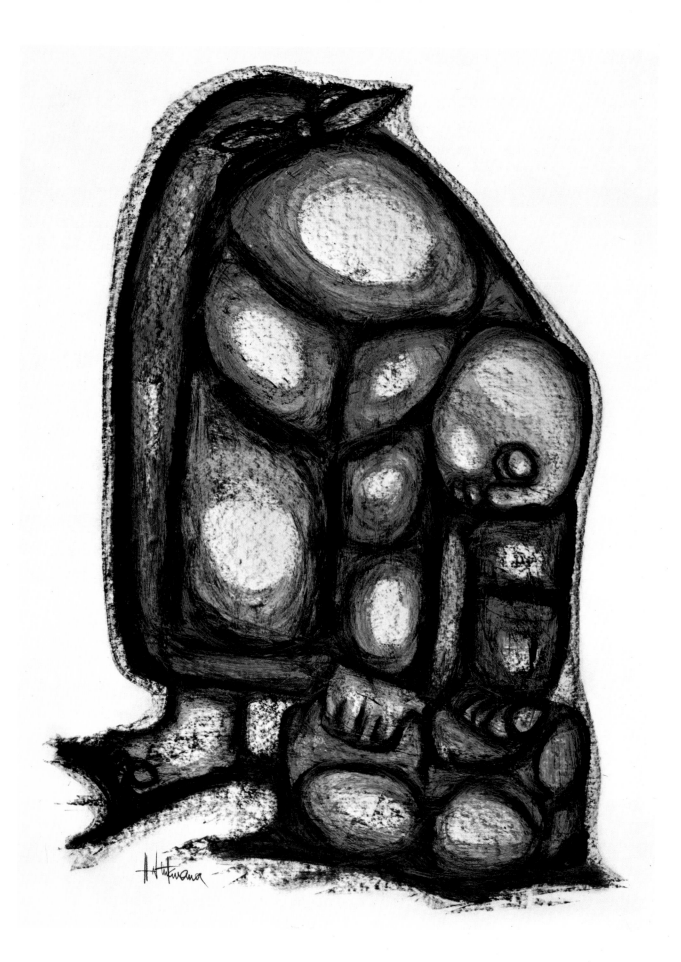

73. NTUKWANA, H. **Composition.** Crayon. 62 x 98 cm.

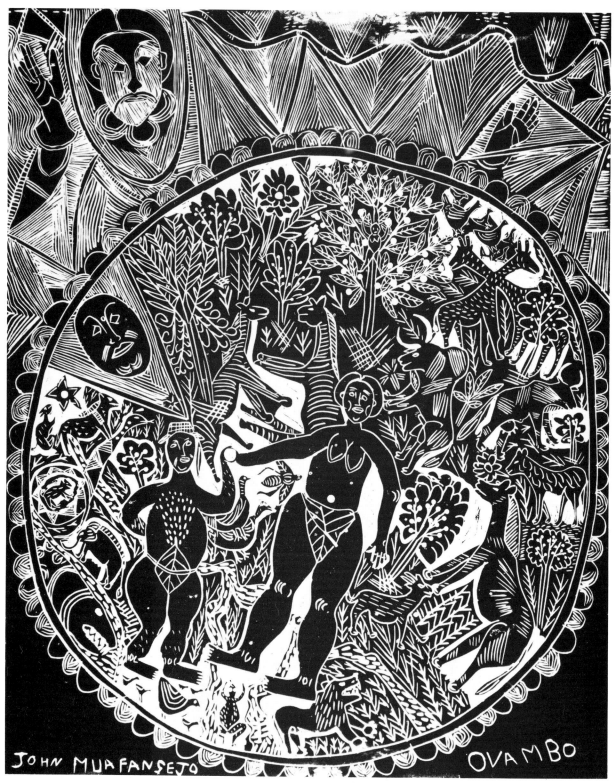

JOHN MUAFANGEJO

OVAMBO

74. MUAFANGEJO, J. **Vision of Eden.** 1968. Linocut. 62 x 53 cm.

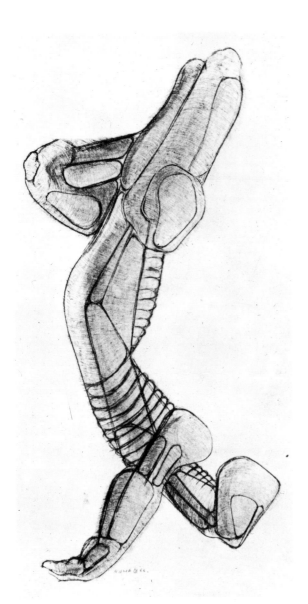

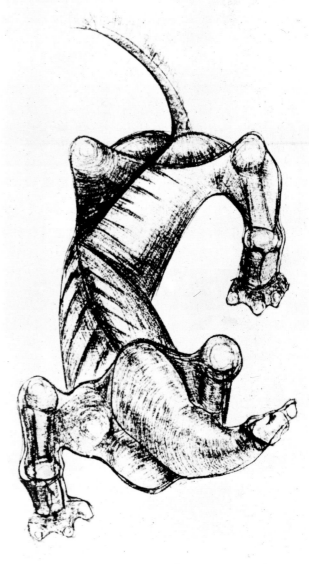

75. KUMALO, S. **Animal**. 1966. Chalk. 36 x 57 cm.

76. KUMALO, S. **Animal**. 1966. Chalk.

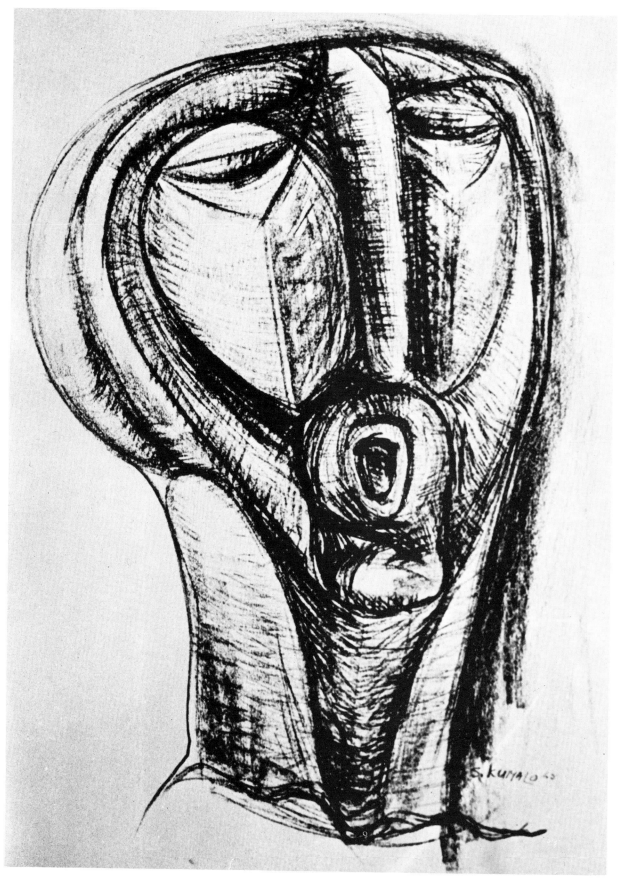

77. KUMALO, S. **Head**. 1965. Chalk.

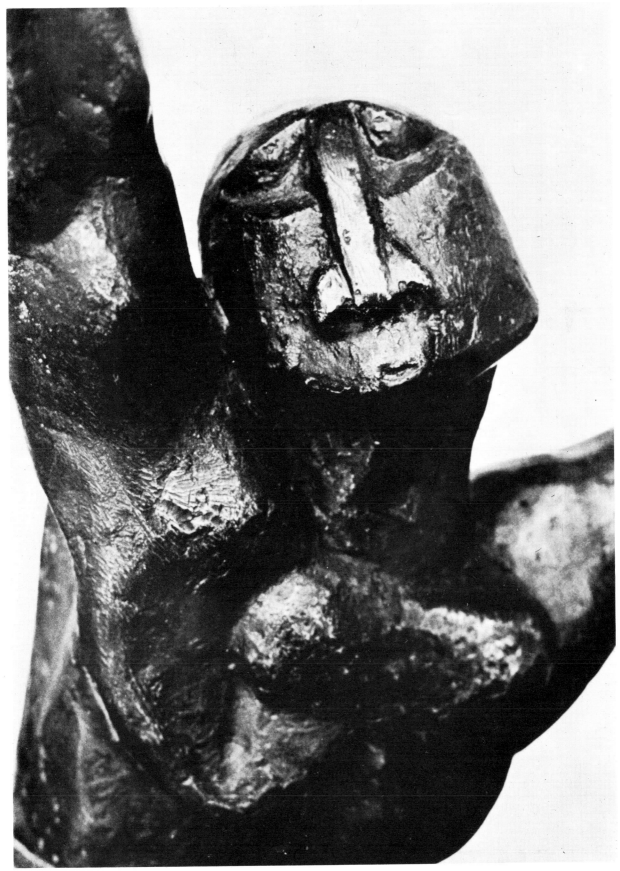

78. KUMALO, S. **The Dancer** (detail). 1965. Bronze. 46 cm.

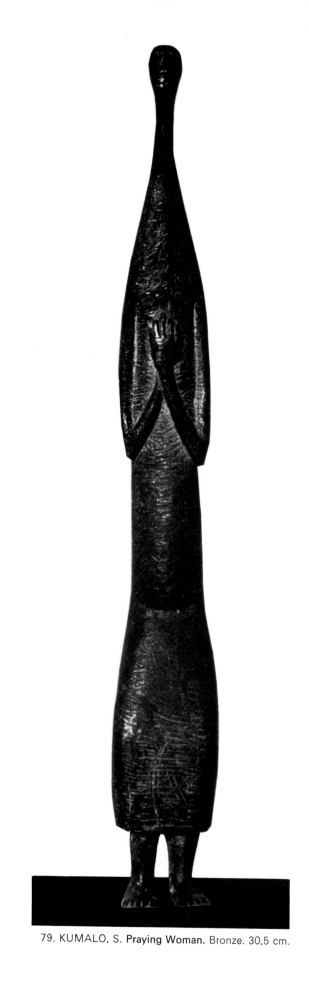

79. KUMALO, S. **Praying Woman.** Bronze. 30,5 cm.

80. KUMALO, S. **Zulu Chief.** 1963. Bronze. 66,5 cm.

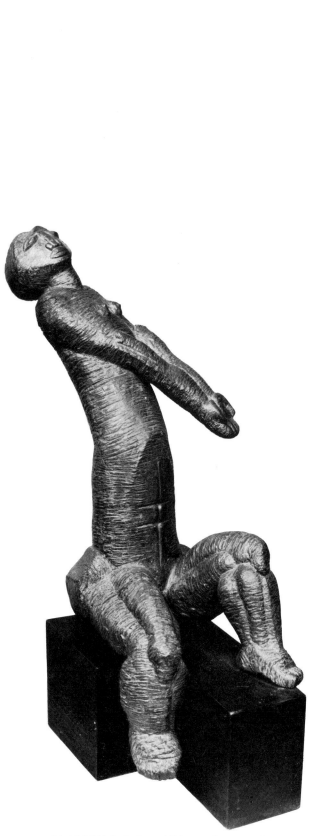

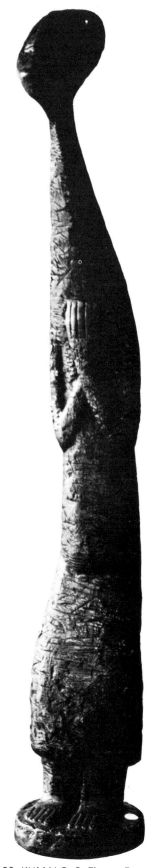

81. KUMALO, S. **Seated Woman.** Bronze. 56 cm.

82. KUMALO, S. **Figure.** Bronze.

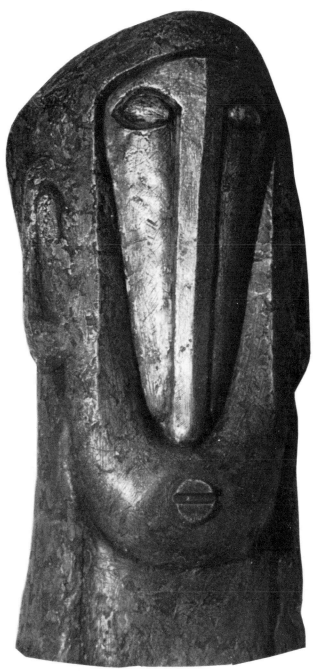

83. KUMALO, S. **Elongated Head.** Bronze.

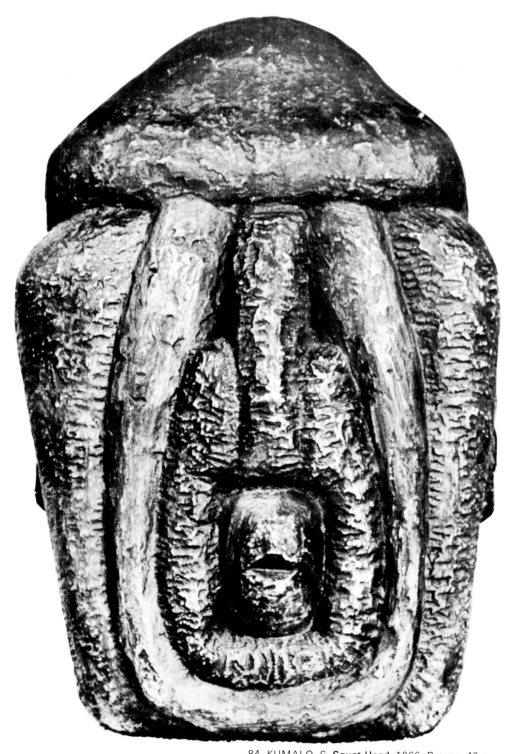

84. KUMALO, S. **Squat Head.** 1966. Bronze. 46 cm.

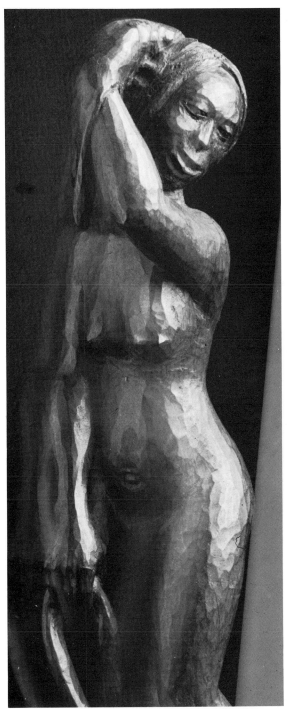

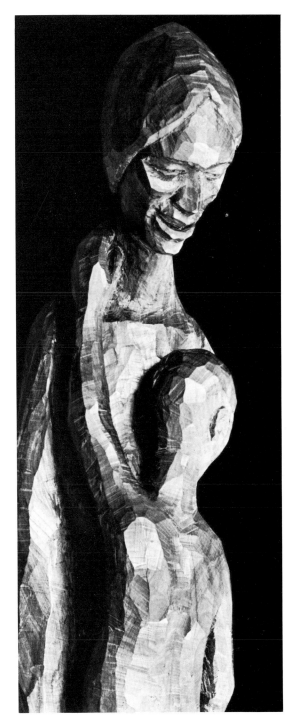

85. ZONDI, MICHAEL. **Woman Bathing.** Umthombothi.

86. ZONDI, MICHAEL. **Madonna and Child.** Red Ivory.

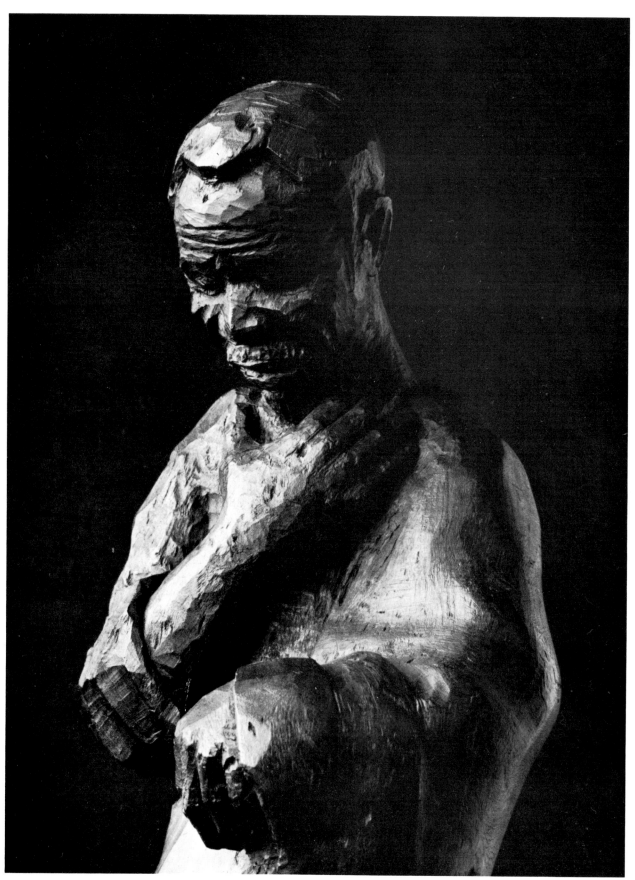

87. ZONDI, MICHAEL. **The Publican.** (Detail). Stinkwood.

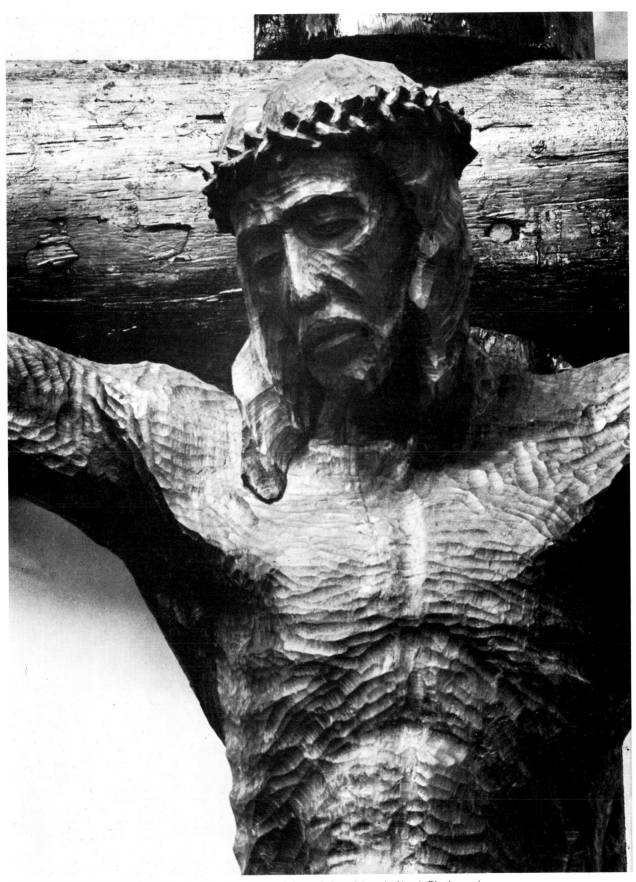

88. ZONDI, MICHAEL. Detail. Life-size Crucifix, Hospital Chapel, Appelsbosch, Natal. Blackwood.

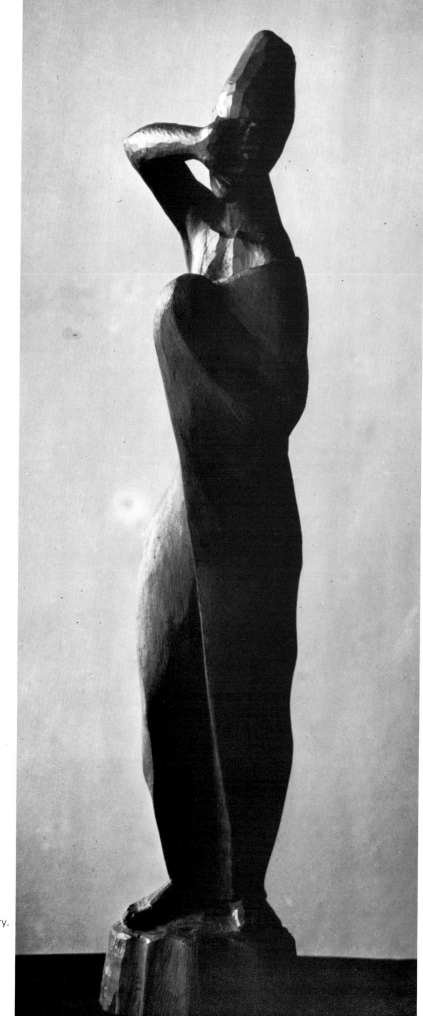

89. ZONDI, MICHAEL. **Rachel.** Red Ivory.

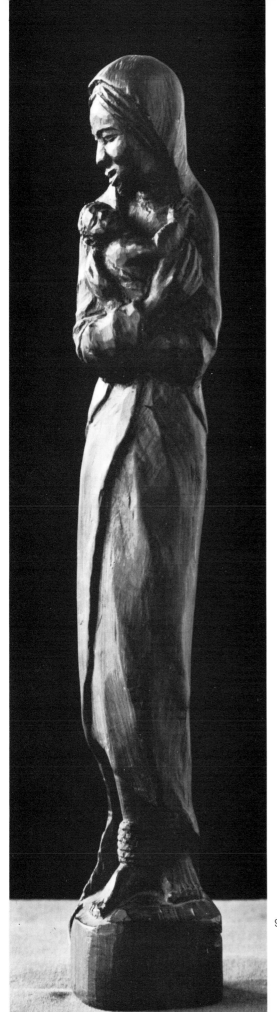

90. ZONDI, MICHAEL. **Mother and Child.** Umthombothi.

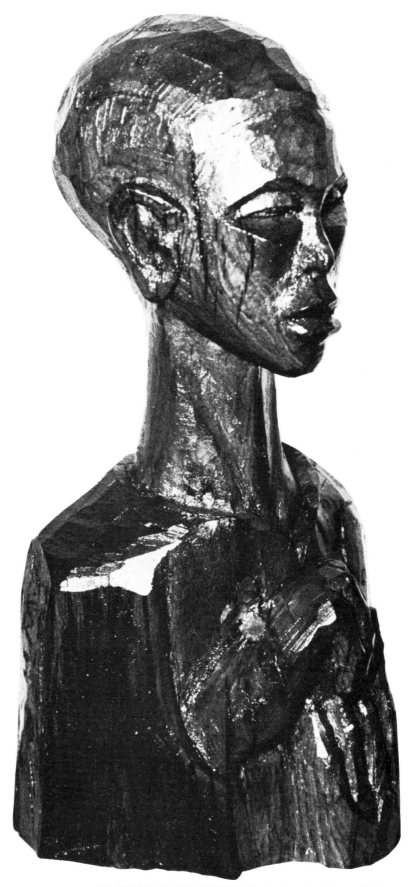

91. ZONDI, MANDLENKOSI. **The Orphan.** Red Ivory. 25,5 cm.

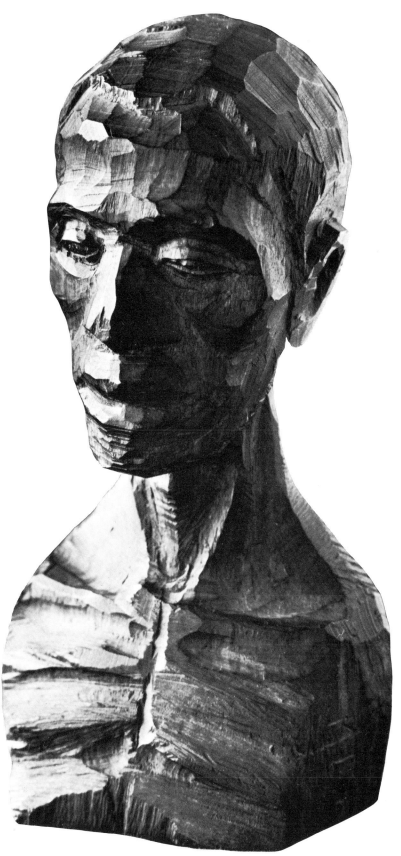

92. ZONDI, MICHAEL. **Portrait of a Dying Man.** Umthombothi.

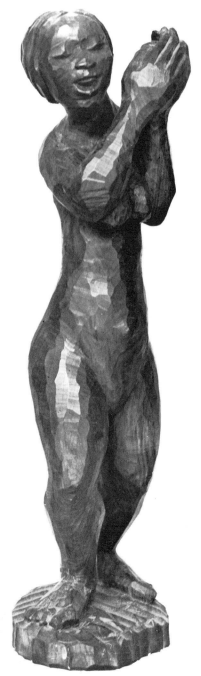

93. ZONDI, MICHAEL. **Ecstatic Woman.** Umthombothi. 46,5 cm.

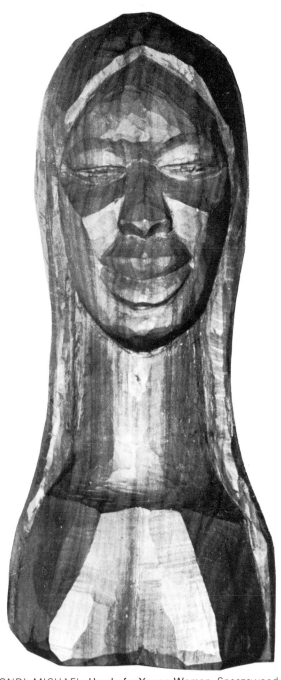

94. ZONDI, MICHAEL. **Head of a Young Woman.** Sneezewood. 38 cm.

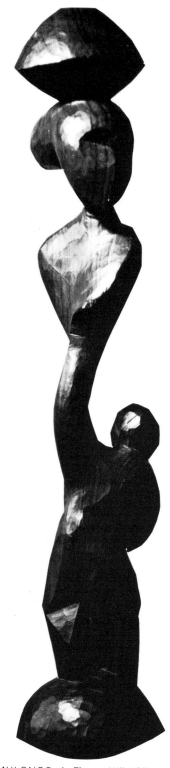

95. MHLONGO, A. **Figure.** Wild Olive. 43,2 cm.

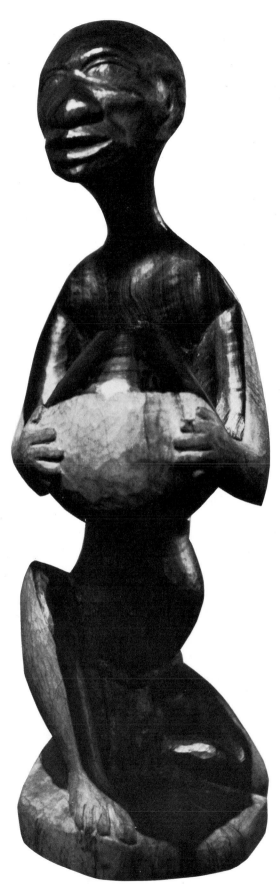

96. MHLONGO, A. **Man with a Beerpot.** Umthombothi. 40,5 cm.

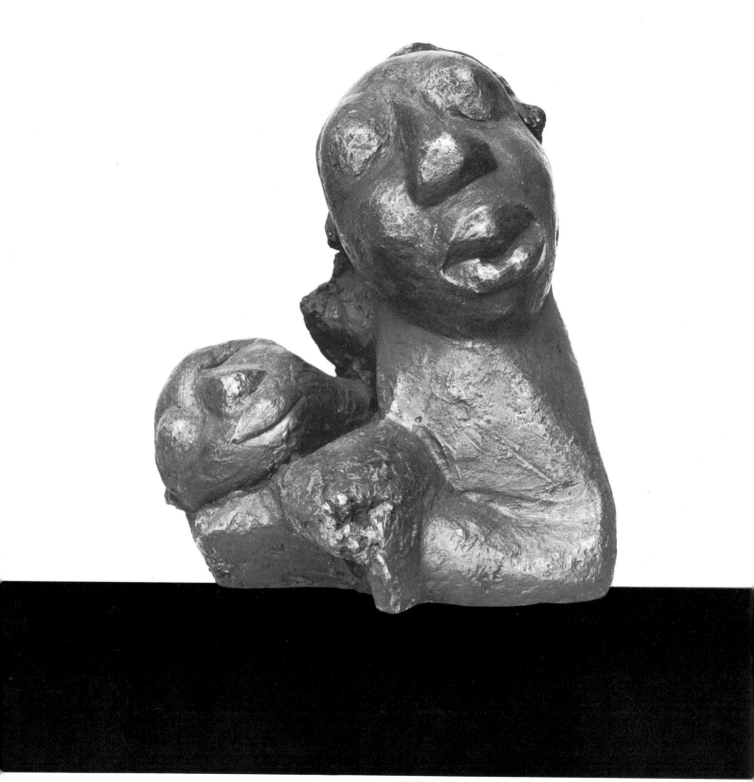

97. MACALA, B. **Mother and Child.** Bronze. 37 cm.

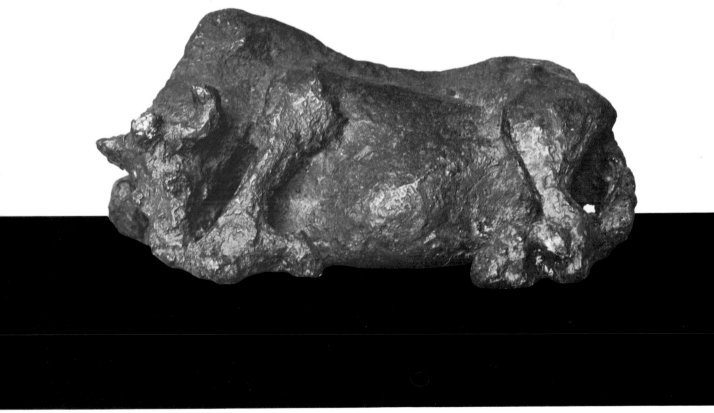

98. MACALA, B. **Bull.** Bronze. 12,5 cm.

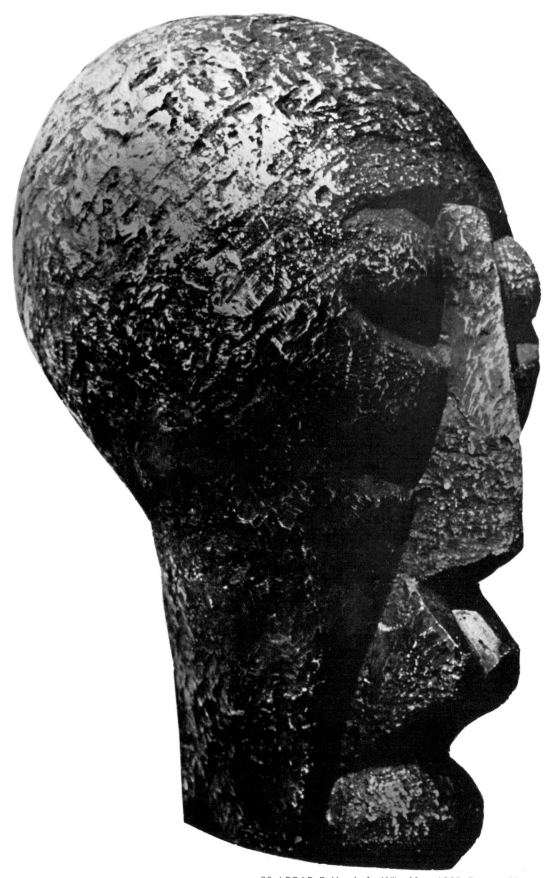

99. LEGAE, E. **Head of a Wise Man.** 1965. Bronze. 33 cm.

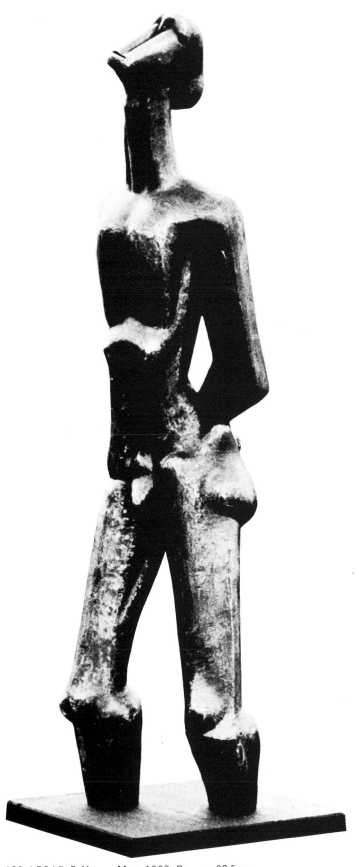

100. LEGAE, E. **Young Man.** 1968. Bronze. 63,5 cm.

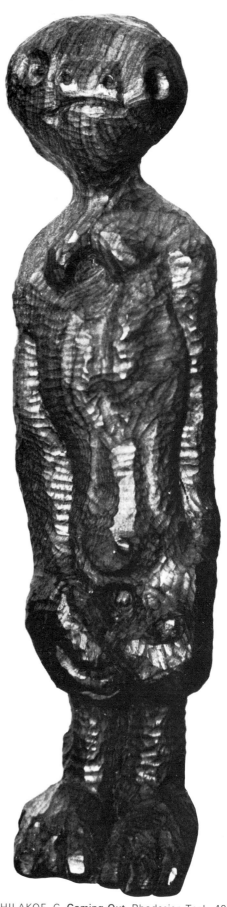

101. SHILAKOE, C. **Coming Out.** Rhodesian Teak. 48 cm.

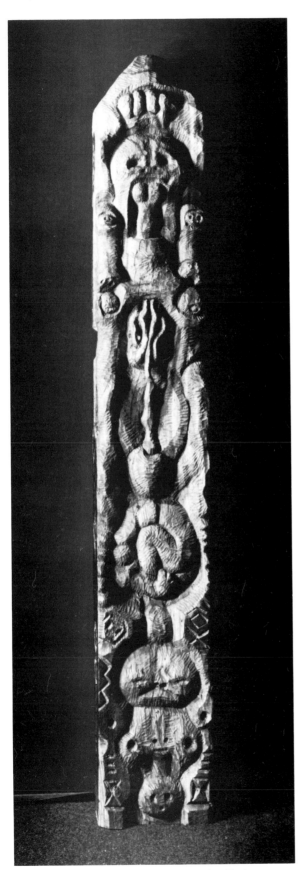

102. SHILAKOE, C. **Totem Pole.** Rhodesian Teak.

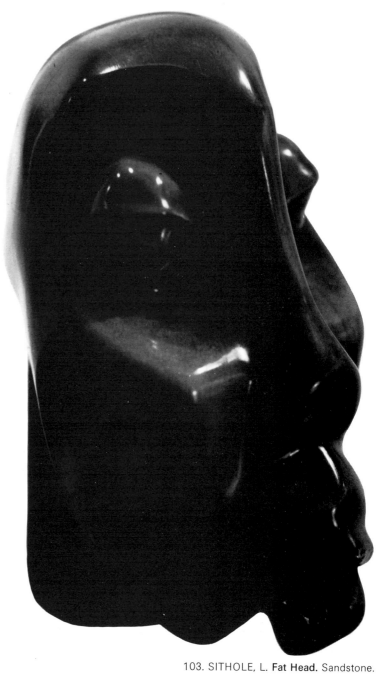

103. SITHOLE, L. **Fat Head.** Sandstone.

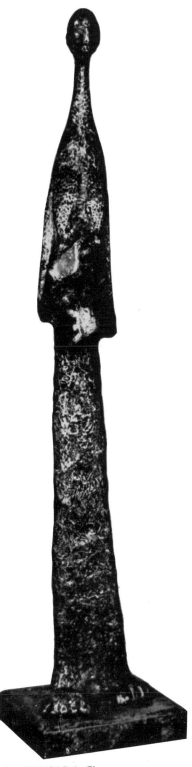

104. SITHOLE, L. **Figure.**

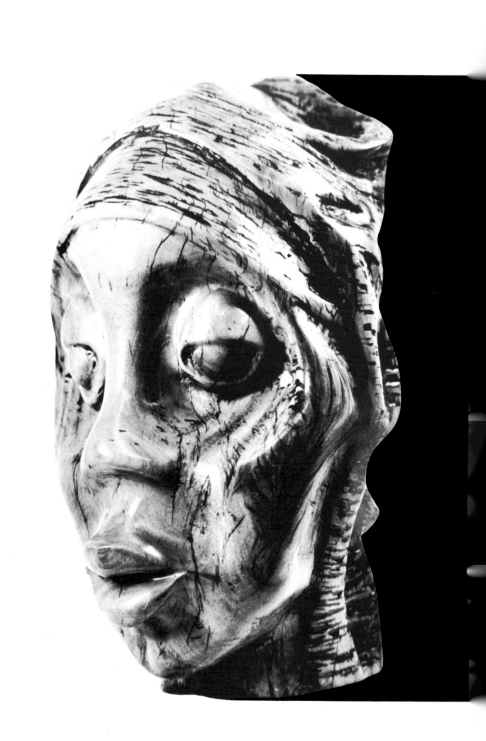

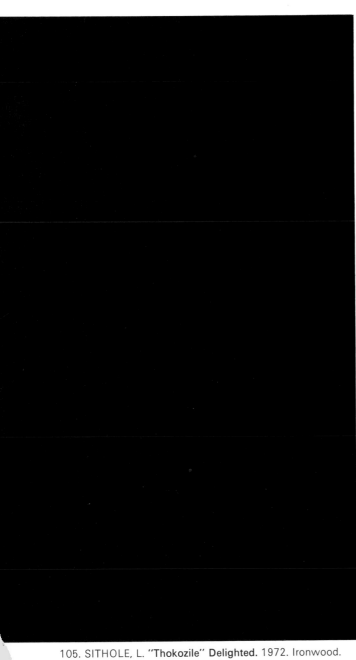

105. SITHOLE, L. "Thokozile" Delighted. 1972. Ironwood.

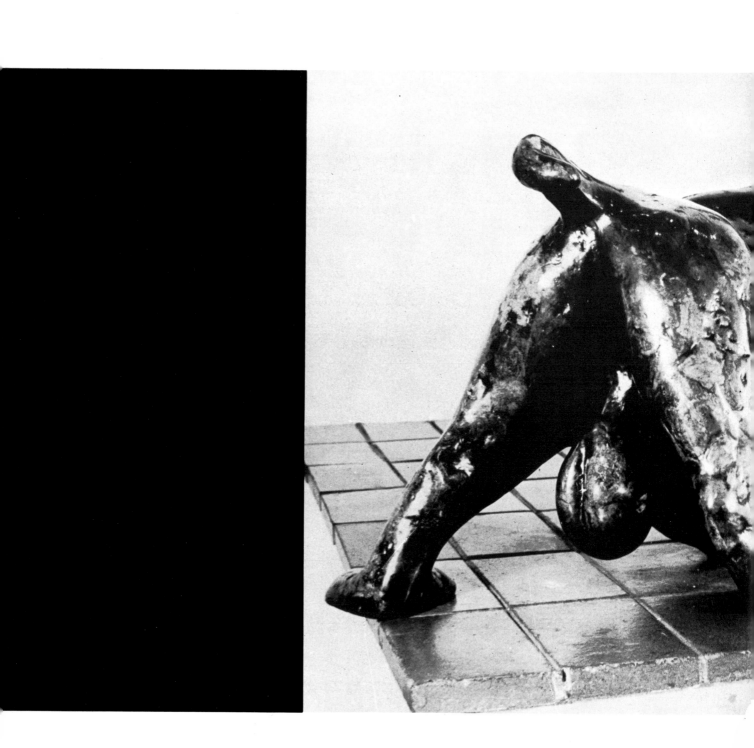

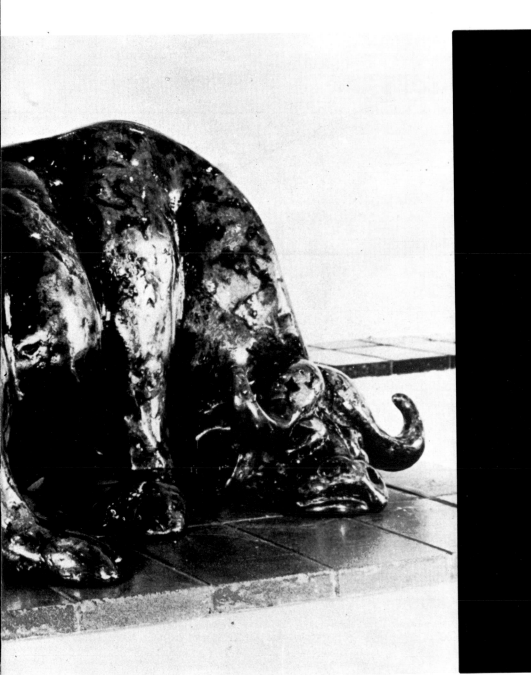

106. SITHOLE, L. **Wounded Buffalo.** 1971. Liquid Steel. Maquette for 27,7 x 1,8 m

107. SITHOLE, L. Group of Figurative Sculptures.

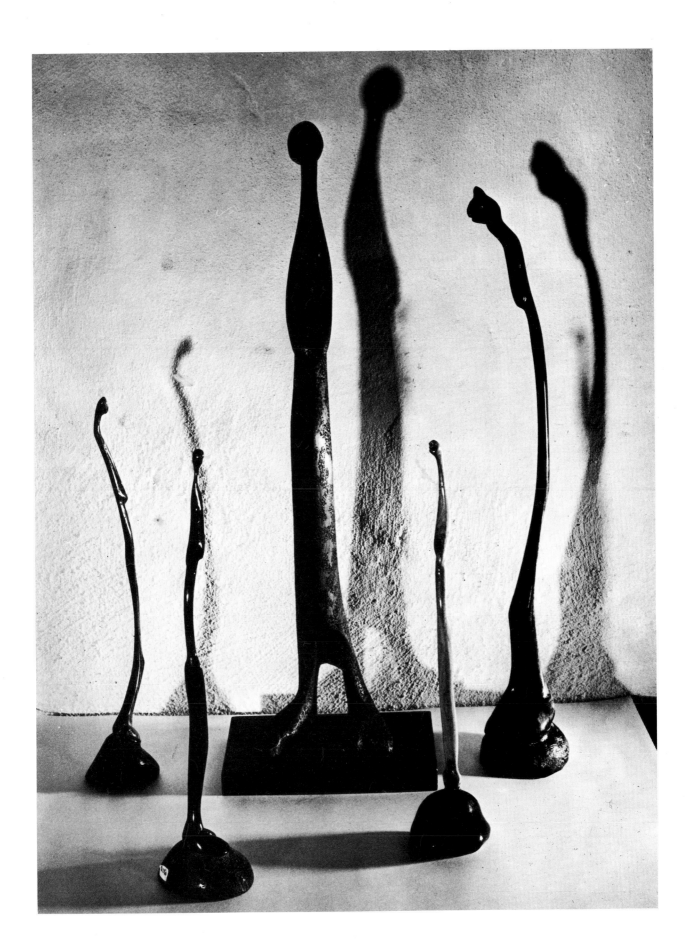

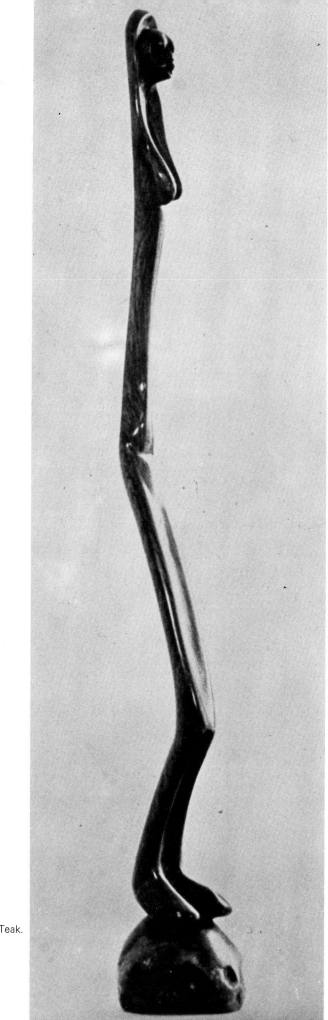

108. SITHOLE, L. **Figure.** Rhodesian Teak.

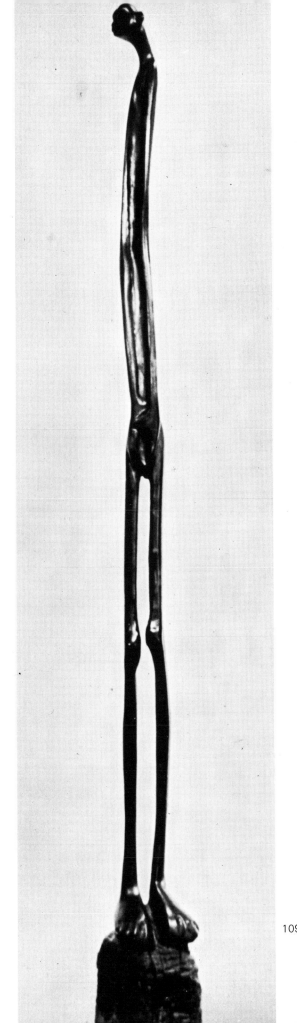

109. SITHOLE, L. **Figure.** Rhodesian Teak.

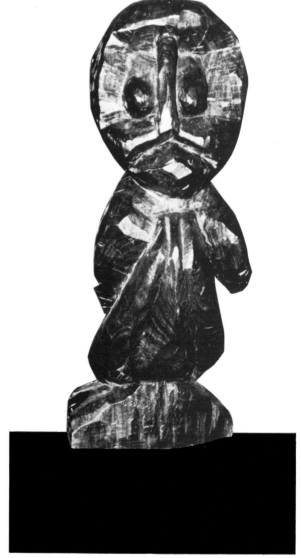

110. MOLATANA, K. **The Mourner.** Umthombothi. 26,5 cm.

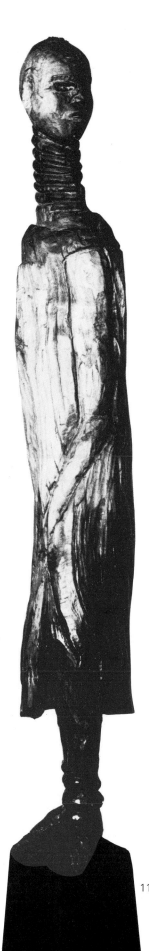

111. MOLATANA, K. **Namasumbuka.** Katbosboom. 85 cm.

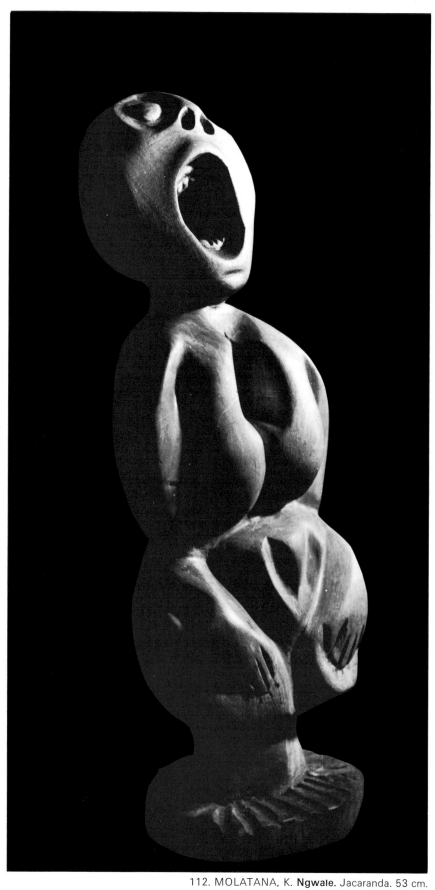

112. MOLATANA, K. **Ngwale.** Jacaranda. 53 cm.

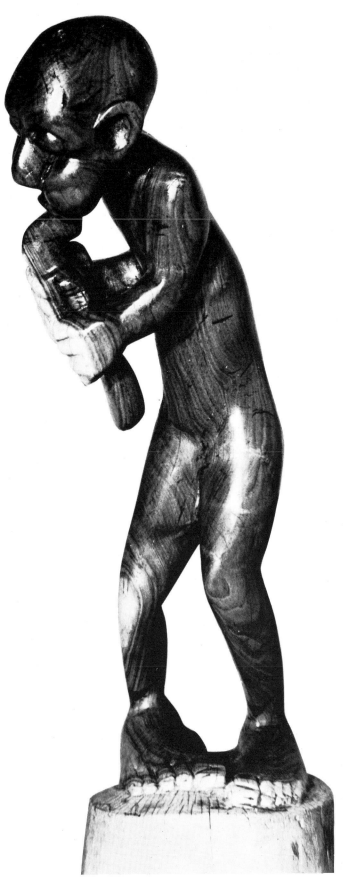

113. KHALISHWAYO, R. **The Flutist.** 1972. Umduli. 56 cm.

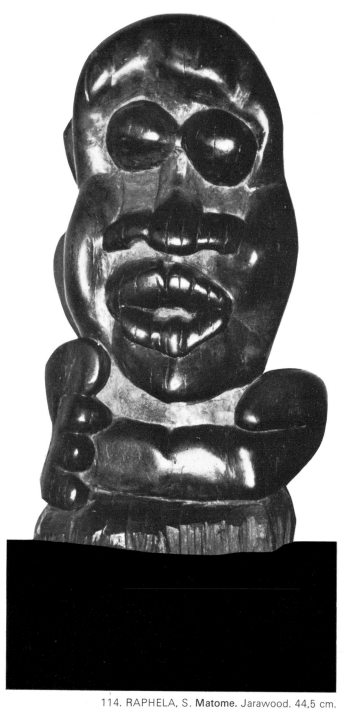

114. RAPHELA, S. **Matome.** Jarawood. 44,5 cm.

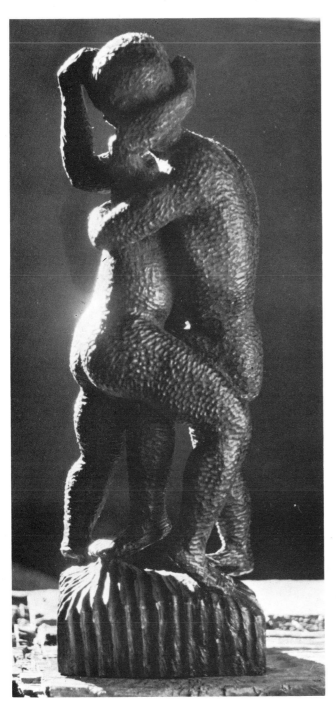

115. SEDIBANE, S. **The Wrestlers.** 1959. Ironwood. 38 cm.

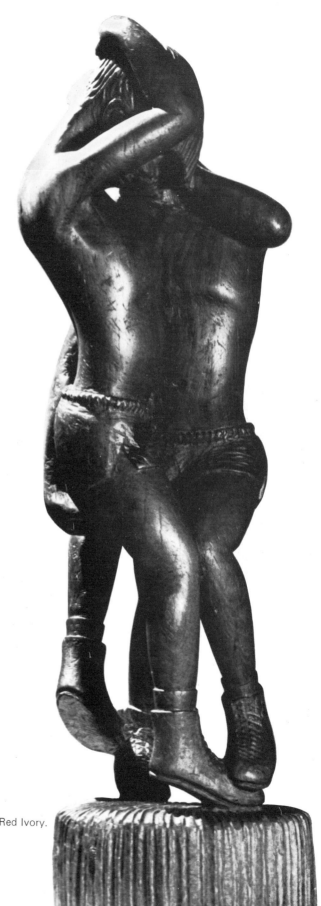

116. SEDIBANE, S. **Wrestlers.** Red Ivory.

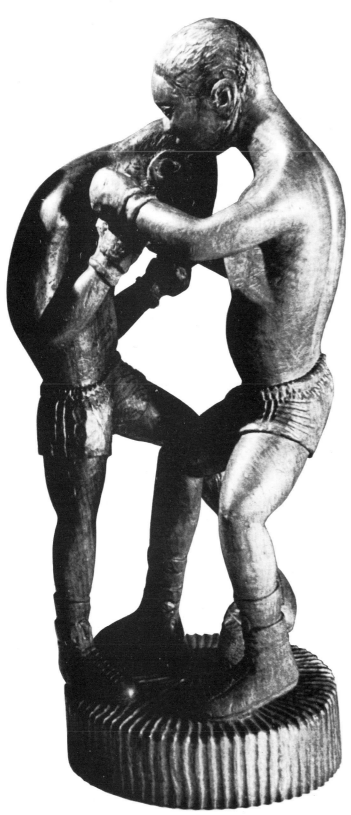

117. SEDIBANE, S. **The Boxers.** Red Ivory.

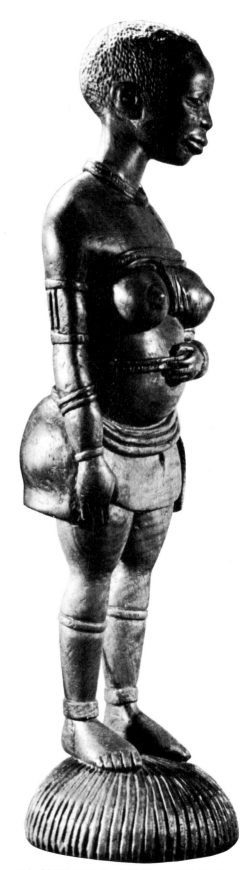

118. SEDIBANE, S. **North Sotho Girl.** Red Ivory.

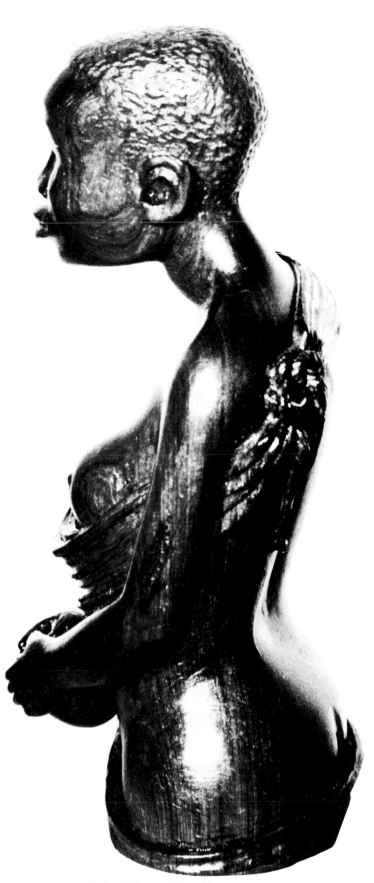

119. SEDIBANE, S. **Pedi Woman.** Kiaat. 34 cm.

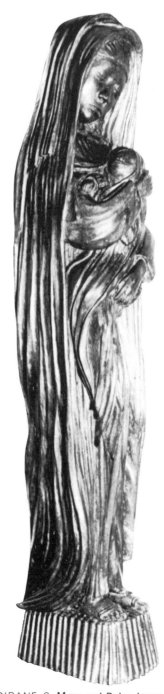

120. SEDIBANE, S. **Mary and Baby Jesus.** Red Ivory.

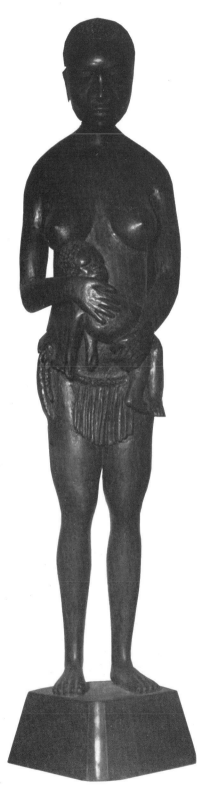

121. SEDIBANE, S. **The Dying Child.** Kiaat.

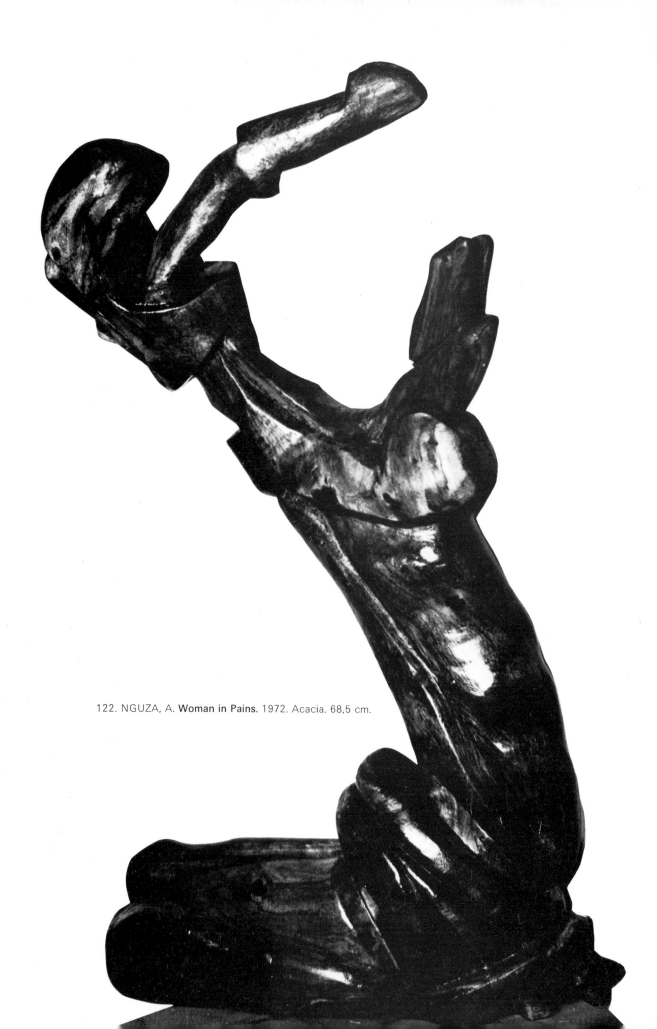

122. NGUZA, A. **Woman in Pains.** 1972. Acacia. 68,5 cm.

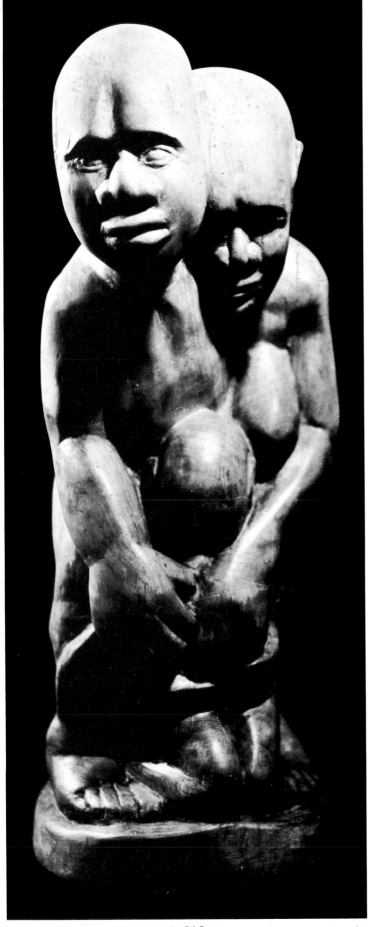

123. NDABA, G. **Family.** Jacaranda. 54,5 cm.

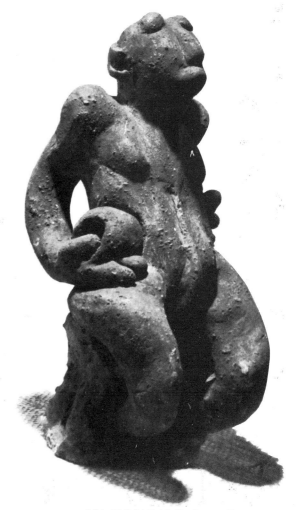

124. DUMILE, M. **Sculpture.** Terra Cotta.

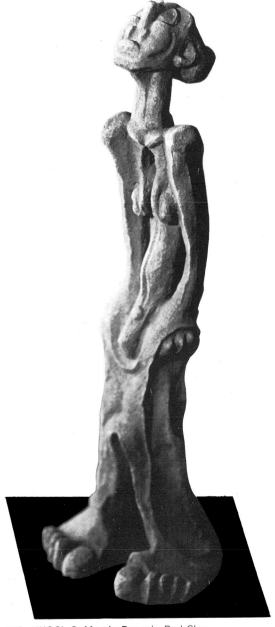

125. NKOSI, S. **Man in Despair.** Red Clay.

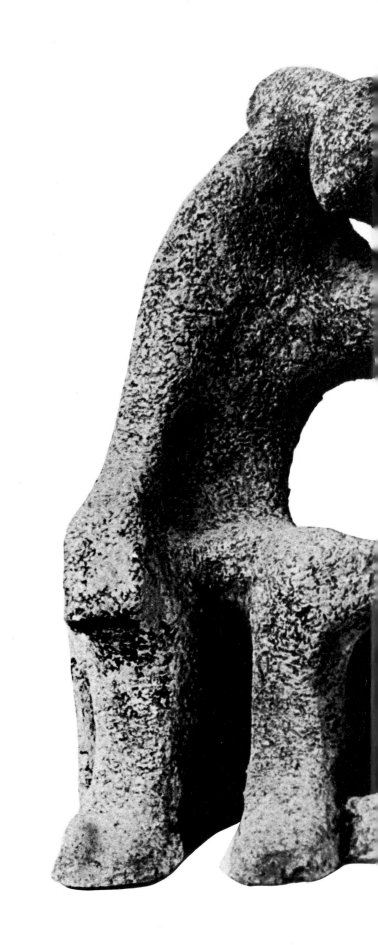

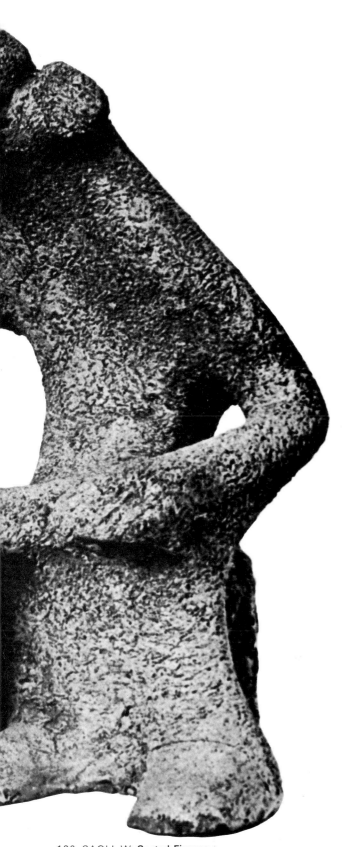

126. SAOLI, W. **Seated Figures.**

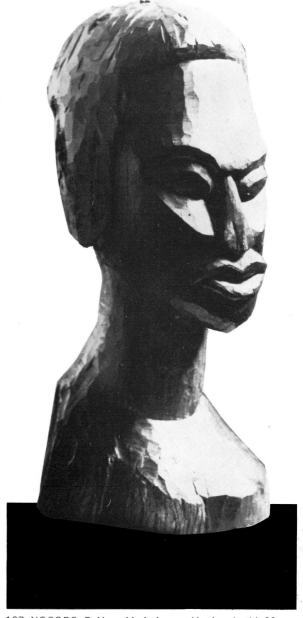

127. NGCOBO, E. **Unomkhubulwana.** Umthombothi. 38 cm.

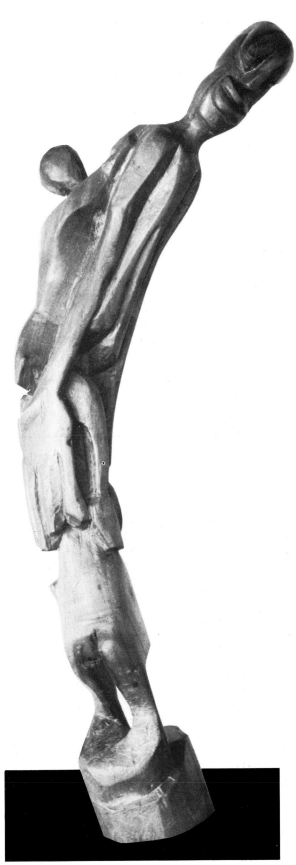

128. MLAMBO, P. **The Cradle.** Red Ivory. 84 cm.

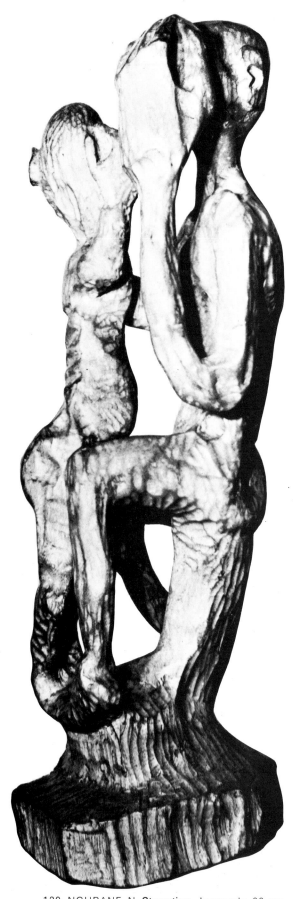

129. NGUBANE, N. **Starvation.** Jacaranda. 66 cm.